Magic Lantern Guides®

Canon

PowerShot
G10

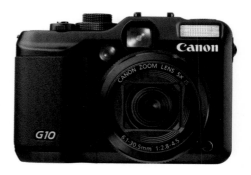

Jason Schneider

LARK BOOKS

A Division of Sterling Publishing Co., Inc.
New York / London

Book Design and Layout: Michael Robertson
Cover Design: Thom Gaines – Electron Graphics

Library of Congress Cataloging-in-Publication Data

Schneider, Jason, 1942-
 Canon powershot G10 / Jason Schneider. -- 1st ed.
 p. cm. -- (Magic lantern guides)
 Includes index.
 ISBN 978-1-60059-540-0 (pbk. : alk. paper)
 1. Canon digital cameras. 2. Photography--Digital techniques. I. Title.
 TR263.C3S36 2009
 771.3'3--dc22

10 9 8 7 6 5 4 3 2 1
First Edition

Published by Lark Books, A Division of
Sterling Publishing Co., Inc.
387 Park Avenue South, New York, N.Y. 10016

Text © 2009, Jason Schneider

Magic Lantern Guides® is a registered trademark of Sterling Publishing Co., Inc.

Distributed in Canada by Sterling Publishing,
c/o Canadian Manda Group, 165 Dufferin Street
Toronto, Ontario, Canada M6K 3H6

Distributed in the United Kingdom by GMC Distribution Services,
Castle Place, 166 High Street, Lewes, East Sussex, England BN7 1XU

Distributed in Australia by Capricorn Link (Australia) Pty Ltd.,
P.O. Box 704, Windsor, NSW 2756 Australia

If you have questions or comments about this book, please contact:
Lark Books
67 Broadway
Asheville, NC 28801
(828) 253-0467

Manufactured in USA

ISBN 13: 978-1-60059-540-0

For information about custom editions, special sales, premium and corporate purchases, please contact Sterling Special Sales Department at 800-805-5489 or specialsales@sterlingpub.com.

Contents

The Canon PowerShot G10 ... 13
An Innovative Return to Classic Form 13
A Great New LCD Screen .. 15
Traditional Controls and Styling 15
Separate Optical Zoom Finder .. 16
Manual Controls for Serious Shooters 17
Other New and Upgraded Features 17
The Big Picture .. 18

Getting Started with the G10 .. 23
Easy Steps for Using Your Camera Now 23
Attach the Neck Strap .. 23
The Battery and Memory Card 23
Set the Date, Time, and Language 26
Set the Language .. 27
Shooting Still Images in AUTO Mode 27
Shooting Tip - Image Sharpness 29
Viewing Still Photographs .. 30
Erasing Images .. 30
Printing .. 30
Shooting Movies using Standard Mode 32
Downloading Images to a Computer 33

Basic Features and Operations ... 37
The Optical Viewfinder .. 37
Canon G10 – Front View .. 38
Canon G10 – Rear View ... 39
Canon G10 – Top View .. 40
LCD Screen – Shooting Mode .. 41
LCD Screen – Playback Mode .. 42
The LCD Screen ... 43
 Information Display .. 43

Playback Mode .. 43
Screen Brightness .. 43
Night View .. 44
LED Indicators ... 44
Upper LED .. 44
Lower LED .. 45
ISO .. 45
Setting the ISO .. 46
Image Quality .. 46
Shutter Speed ... 46
Flash Range .. 47
Image Stabilization (IS) .. 47
Camera Shake Warning & Auto ISO Shift 47
The Mode Dial ... 48
AUTO Mode .. 49
Program AE Mode ... 49
Shutter Speed Mode ... 50
Aperture Mode .. 50
Manual Mode .. 50
C1 and C2 (Saving Custom Settings) 50
SCN Modes ... 50
Panoramic Images and Stitch Assist 51
Movie Shooting ... 52
The Control Dial .. 53
Menus Overview ... 54
Playback .. 55
File Formats .. 55
JPEG ... 55
RAW .. 56
Quality and Resolution ... 57
Recording Pixels .. 57
Compression ... 59

The FUNC. Menu ... 61
Navigating the FUNC. Menu .. 62
White Balance (WB) ... 63
My Colors .. 65
Bracket .. 66
Flash Exposure Compensation ... 68
ND (Neutral Density) Filter .. 68

Compression .. 69
Recording Pixels ... 70

Shooting Mode Menus 73
Rec. Menu ... 74
 AF Frame ... 74
 AF-Point Zoom ... 74
 Servo AF .. 75
 AF Mode ... 76
 Digital Zoom .. 76
 Flash Control 76
 i-Contrast .. 78
 Drive Settings 78
 Spot AE Point ... 79
 Safety Shift .. 79
 Auto ISO Shift .. 79
 MF-Point Zoom ... 80
 AF-Assist Beam .. 80
 Review ... 80
 Review Info ... 80
 Record RAW + JPEG ... 81
 Auto Category .. 82
 IS Mode .. 83
 Converter .. 83
 Custom Display 83
 Set Shortcut button 84
 Save Settings 85
Set Up Menu .. 86
 Mute ... 87
 Volume 87
 Audio 87
 LCD Brightness .. 89
 Power Saving 89
 Time Zone ... 90
 Date/Time ... 91
 Clock Display ... 91
 Format 91
 File Numbering ... 92
 Create Folder 92
 Auto Rotate ... 94

Distance Units .. 94
Lens Retract .. 94
Language 94
Video System .. 94
Print Method .. 94
Reset All 95
My Camera Menu .. 96
My Menu .. 97
My Menu Settings ... 98

Playback Mode Menus .. 101
The Play Menu .. 101
Slide Show 102
My Category 103
Erase 105
Protect 106
i-Contrast 108
Red-Eye Correction 108
Trimming 110
Resize 110
My Colors 110
Sound Recorder 111
Rotate 112
Transfer Order 112
Resume .. 112
Transition ... 112
Print Menu ... 113
Print 113
Select Images & Qty 114
Select Range 115
Select by Date 115
Select by Category. 116
Select by Folder 116
Select All Images 116
Clear All Selections 116
Print Settings 116
Set-up Menu .. 118
My Camera Menu .. 118

Drive Modes and Focusing ... 121

Drive Modes ... 121

 Single Shot ... 121

 Continuous Shooting Modes ... 122

Autofocus Mode ... 122

 AF Frame Mode .. 123

 Moving the AF Frame ... 125

 Servo AF-Focus Tracking ... 126

 The Face Detect Feature ... 126

 Zooming to Check Focus .. 128

 Shooting Hard-to-Focus Subjects ... 129

 Focus Bracketing Mode ... 130

 Macro Mode ... 131

Manual Focus Mode (MF) ... 133

 Manual Focus Plus AF ... 134

Exposure, White Balance, and In-Camera Adjustments 137

Exposure ... 137

 Metering ... 138

 Exposure Compensation .. 140

 AEB (Autoexposure Bracketing) Mode 141

 AE Lock .. 141

 Exposure Modes – Get in Control .. 142

 The Scene Modes .. 148

White Balance (WB) .. 149

 Custom White Balance Tips .. 152

In-Camera Adjustments .. 152

 i-Contrast ... 152

 Neutral Density (ND) Filter .. 153

 My Colors .. 154

 Changing Colors in Captured JPEG Images 155

Playback Mode ... 159

Viewing Images ... 160

 Index Playback ... 160

 Magnified Display .. 161

 Focus Check Display .. 162

 Jumping to Images .. 163

 Slide Shows .. 164

My Categories .. 165

Erasing Images ... 166
Protecting Images .. 167
In-Camera Adjustments .. 167
 i-Contrast .. 167
 Red-Eye Correction .. 168
 Trimming .. 168
 Resizing Images .. 170
 Adding Color Effects to Recorded JPEGs 170
 Attaching Sound to Images 170
 Rotate Images in Playback 172
Movies ... 172
 Viewing Movies on TV 173
 Editing Movies .. 174

Flash and Accessories .. 177
Built-In Flash Modes ... 177
 FE Lock ... 179
 Using an Externally Mounted Flash 180
 Taking Photos with an External Flash Unit 182
 Speedlite 220EX Settings 183
 Speedlite 430EX II/580EX II Settings 184
Using the TC-DC58D Teleconverter 185
 Converter Settings Using Image Stabilization (IS) 188

Index ... 190

Photo © Kevin Kopp.

The Canon PowerShot G10

An Innovative Return to Classic Form

The Canon PowerShot G10 is the latest in Canon's popular G-series of compact, full-featured, high-performance digital cameras. Begun in 2000 with the G1, the series was designed following a straightforward, elegant, eminently successful concept: to provide digital compact cameras with features and performance aimed at professionals and serious photography enthusiasts. When one considers that the original PowerShot G1 had a 3-megapixel sensor and sold for $1,100—more than twice the price of the current G10—the phenomenal advance of digital photography technology becomes very apparent. Indeed, it is hardly surprising that the PowerShot G10 offers significant benefits in features, performance, and convenience even compared to its worthy, similar-looking immediate predecessor, the PowerShot G9.

To understand what makes the PowerShot G10 such a technological tour de force, and arguably the best performing digital compact camera ever, it helps to examine those features that distinguish it from the G9. The most obvious is the lens: a fast, 5x, 6.1-30mm f/2.8-4.5 zoom (which offers an equivalent view to a 28-140mm zoom on a 35mm full-frame camera). This lens, for the first time in a G-series

The Powershot G10 hit the photography world running—and for good reason. It features an impressive 14.7 megapixel sensor, image stabilization, and Canon's outstanding image processing and noise control technology. Most important, the camera has the feel of a finely machined camera costing many times its price. Turning the solid, knurled dials takes one back to the days of precision film cameras.

camera, offers true wide-angle with 75° coverage. To keep the lens within the established medium compact form factor without compromising lens speed, the telephoto end of the zoom had to be trimmed back from the G9's 7.4-44.4mm f/2.8-4.8 (35mm full-frame equivalent: 35-210mm). However, for the vast majority of shooters, having expanded wide-angle ability is far more important than having a moderate amount of extra reach—it extends the camera's potential subject range considerably, especially when shooting landscapes, indoor images, and groups of people. And you can still get expanded telephoto coverage by mounting the dedicated 1.4x Canon TC-DC58D teleconverter.

The next significant enhancement is the G10's 14.7MP (megapixel) CCD sensor, which is an increase in resolution over the G9's 12.2MP. The sensor dimension of 1/1.7 inches (2.5/4.3 cm) remains the same—it's the largest size generally fitted into digital compact cameras but considerably smaller than the APS-C size found in most consumer digital SLRs (D-SLRs) including those from Canon. What enables the camera to perform to a very high standard at such elevated pixel densities is Canon's acclaimed Digic 4 image-processing system, the same one used in current high-end Canon D-SLRs such as the EOS 5D Mark II. The Digic 4 is a prime component behind the G10's upgraded performance, including its very short shutter lag and startup times, enhanced Face Detection system that can lock on to faces that are tilted or in profile, vastly improved continuous sequence shooting ability, Servo AF with focus tracking (a first in a PowerShot camera) and improved overall image quality, especially at high ISO settings. At up to ISO 400, the compact G10 performs on par with current D-SLRs with similar megapixel ratings—a spectacular achievement. Only at ISO 800 and, to a greater extent at ISO 1600, do the benefits of having a larger sensor become visibly apparent (larger pixels result in less noise). The G10 also has an upgraded battery capacity, providing approximately 400 images per charge (based CIPA standards), up from 240 on the G9.

A Great New LCD Screen

Another important upgrade to the G10 is its wide-view 100%-coverage LCD, another feature that merits best-in-class honors. It's the same size—3.0 inches (7.62 cm) diagonally—as the one in the G9, but it displays 461,000 pixels, or twice the resolution. As a result, the G10's LCD is amazingly crisp and detailed, a fact noticed even by non-technical observers. This makes it far superior for composing or reviewing pictures and assessing details. The G10 can be easily set to provide a magnified view of whatever is in the autofocus (AF) frame. By pressing the **MENU** button, selecting the Rec. Menu 🔘 in the Shooting mode, scrolling to [AF Frame] and setting it to [Flexizone], the image area in the AF frame will be magnified when you press the shutter release partway in—a very useful feature for assessing details on the fly prior to taking the picture. This, combined with its excellent sharpness, automatic Night Display, and individual brightness adjustments, makes it a superior image-control device that superbly facilitates the whole picture-taking process and takes it to a higher level.

Traditional Controls and Styling

In keeping with the G-series heritage, the PowerShot G10 looks and feels remarkably like a vintage camera with controls and styling that are similar to cameras of the film era, such as: the knurled bayonet cover on the lens surround, textured analog Mode and ISO dials, a dedicated E-TTL hot shoe for EX-series Speedlites. It also includes an EOS-style Control dial surrounding the four-way controller and the 🔘 button on the back. In addition to the analog ISO and Mode dials present on the G9, the G10 adds a convenient +/-2 stop (in 1/3-stop increments) exposure compensation dial. There are large, detented, and legibly marked manual ISO settings from 80-1600. You can also set the ISO dial to **AUTO** and let the camera select the ISO according to the light level, or **HI**, which will favor higher ISO speeds for faster shutter speeds when action subjects are detected. You can also set the Mode dial to **SCN**, scroll through the usual subject mode options, and select [ISO 3200] for shooting without flash in low light. At that setting, recording pixels are fixed at the Medium 3 image quality level, or 1600x1200 pixels (see page 58).

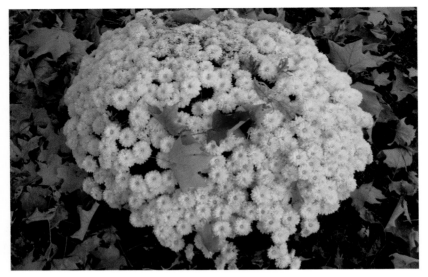

The G10 features a 3-inch (7.62 cm) high-resolution LCD that covers 100% of the image area. The camera also has an optical viewfinder, which is useful for those who like to shoot with the camera braced steadily against their face.

Separate Optical Zoom Finder

Also in the G tradition, the G10 incorporates a small separate optical zoom finder that can help you steady the camera against your face when composing the shot, or conserve battery power by turning off the LCD. To its credit, the optical finder shows a clear image—it appears slightly sharper and clearer than the finder in the G9—and it has a convenient diopter control to the left of the eyepiece for adjusting it to your individual eyesight. A tiny bit of the lens barrel does obtrude into the bottom left-hand portion of the viewing image when the lens is zoomed to the widest-angle position, but this is a minor point for most users. An optical finder is a must-have feature for a camera in this class, and while the one in the G10 is commendably compact and generally satisfactory, it is not up to the very high standard set by the rest of the camera. It shows the image at 0.77x magnification, has rounded corners (unlike the final captured image), and no sight marks, frame lines, or parallax-compensation markings.

Manual Controls for Serious Shooters

The G10 is the only camera in its class to provide true manual focusing capability in a direct and convenient manner—another must for most serious shooters. Just press the clearly labeled **MF** button at the top of the four-way controller on the back, and presto—you're in manual focus mode, as indicated on the LCD by an **MF** icon with green arc-shaped arrows pointing downwards. Now turn the Control dial to the left or right, and a magnified view of whatever is in the AF frame in use is displayed in the center of the LCD and a vertical distance scale (it can be set to feet or meters) appears to the right. To focus, just turn the dial back and forth until the subject area is sharp, and take the shot. Press the **MF** button again or turn the camera off to cancel the **MF** function. This is a truly brilliant execution of what is, on other cameras, often a cumbersome or less precise feature. It makes it easy to focus manually on the fly. It is, of course backed up by the G10's very effective 9-point AF system with Face Detection software that focuses and tracks faces, and exposes them properly even in bad light.

The manual exposure (**M**) mode is also much convenient and intuitive. Set the top-mounted Mode dial to **M**, toggle the four-way controller to the left and right to select the shutter speed (15-1/4000 second) or aperture respectively on the LCD, then turn the Control dial to center a moving dash opposite a vertical exposure index (a digital variant of the traditional match-needle system) to set the proper exposure. Clearly, the manual control systems on the G10 (and the G9 for that matter) have been optimized for actual use with the end-user in mind.

Other New and Upgraded Features

Another useful new G10 feature is i-Contrast, which is activated by setting this clearly labeled item in the ▣ Menu from [Off] to [Auto]. When it's activated and the camera detects excessive contrast in the scene, such as with a backlit subject, it automatically adjusts the contrast level to deliver a more normal looking tonal range. This works like a charm in capturing pleasant looking pictures

in difficult lighting conditions. The upgraded optical IS (image stabilization) system also does an excellent job in minimizing the effects of camera shake at slow shutter speeds when set to Continuous ▣ , and provides alternative settings of Shoot Only ▣ (which turns on the system only when you're taking a shot), Panning ➡ , and Off ▣ .

The Big Picture
Where the Canon PowerShot G10 really excels is sheer image quality, and its performance can only be described as awesome—noticeably better than the G9 (which is very good indeed) and far better than other digital cameras of comparable size and price. This attests to the G10's outstanding lens and image-processing system. Indeed, there are numerous website postings and official on-line tests including hard data and images indicating that the G10 performs on a par with middle-tier and even pro-level D-SLRs with respect to resolution, sharpness, and color differentiation at ISO settings up to 400.

Happily, my own experience in shooting with the Canon PowerShot G10 in the course of researching this book completely corroborates all these extremely positive assessments. When I shot a head-and-shoulders portrait at ISO 100 and f/5.6 with the camera on a sturdy tripod and blew up the subject's eye to simulate a 20x24-inch enlargement on the screen, I was astounded by the detail in the lines of the iris, lashes and subtle skin textures. My results in normal walk-around shooting under a wide variety of lighting conditions were equally impressive. An overwhelmingly high percentage of available light shots taken in daylight, tungsten, and mixed light sources at the Auto WB setting exhibited rich, natural looking, commendably accurate colors, and the built-in flash did an excellent job too, delivering pleasing, well saturated skin tones and reasonably soft lighting in impromptu close-up portraits.

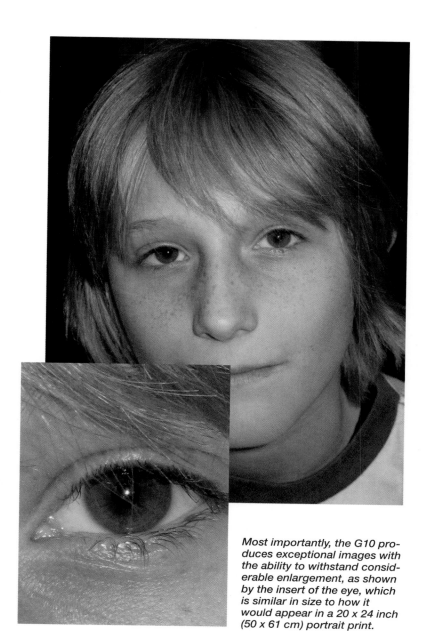

Most importantly, the G10 produces exceptional images with the ability to withstand considerable enlargement, as shown by the insert of the eye, which is similar in size to how it would appear in a 20 x 24 inch (50 x 61 cm) portrait print.

Just because the Canon G10 outperforms virtually any other camera of its size and type hardly means you should ditch your D-SLR. Cameras with larger sensors have definite advantages, and while we didn't perform any side-by-side comparisons, you can rest assured that a Canon EOS 5D Mark II or a Nikon D700 will produce cleaner image files with less noise than the G10 at settings of ISO 800 and above. And in addition to the superior flexibility afforded by lens interchangeability, a D-SLR provides much greater depth-of-field control along with a wider aperture range. The real reason the G10 doesn't stop down farther than f/8 is optical diffraction, which increases dramatically as the physical size of the aperture decreases. The minuscule aperture diameters required for smaller f/stops with a small-sensor camera like the G10 would produce noticeably reduced image quality at these settings.

No camera is perfect of course, but there is little doubt that the Canon PowerShot G10 stands supreme as the best performing digital compact camera in current production, and one of the best ever. It is brilliantly designed, rugged and durable, beautifully made, and it delivers the ultimate in image quality and control. The reason the G10 has taken top honors in the press and on countless user blogs and websites worldwide is not hard to fathom—it's simply the best in its class.

Canon offers an accessory 1.4x Teleconverter TC-DC58D, which will ▷ expand the capability of the G10 dramatically. It is especially beneficial for wildlife, sports, and travel photography. In order to mount the converter, you also need the Conversion Lens Adapter LA-DC58K. Photo © Jeff Wignall.

Getting Started with the G10

Easy Steps for Using your Camera Now

No doubt, you will want to use your G10 right away, so here is our advice on the essential steps in getting started taking great photos.

Attach the Neck Strap

We strongly recommend that you attach the camera's neck strap immediately and use it whenever you are transporting or shooting with your G10. This greatly reduces the risk that you will drop and damage your camera.

To attach the strap, loosen one end from its buckle, slide it through the bottom of the strap mount, and reinsert the end of the strap through the buckle by pulling it over the center bar of the buckle from underneath. Make sure the buckle faces outward and that the Canon and PowerShot G10 logos on the strap read correctly when the back of the camera faces you. Keep the strap straight (untwisted) and thread the other end of the strap through the opposite strap mount in the same manner.

The Battery and Memory Card

To access the battery and memory card chamber, hold the camera with its bottom plate facing upwards and the lens pointing toward you, push the textured finger grip on the end of the right-hand side all the way to the right, and the hinged battery/card compartment cover will spring open.

◁ *The G10 is powered by a rechargeable lithium-ion battery. If you are planning a trip, we advise you to purchase a spare so you won't have to worry about running out of power at important moments. Photo © Jeff Wignall.*

The lithium-ion battery slips easily into its chamber on the bottom of the camera. It is always a good idea to have a spare battery charged and ready for use.

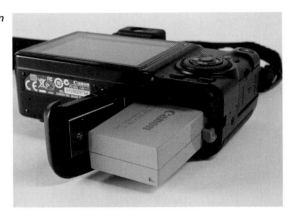

The Battery: The G10 is powered by the NB7L lithium-ion battery. It can also be operated using the optional ACK-DC50 AC Adapter. Out of the box, the battery will need to be charged. It should be recharged after use. The battery does not have "memory" so you can perform a "top-up" charge any time without diminishing its performance.

The G10 battery charger CB-2LZ (110-240V AC, 50/60 Hz) has an integral twist-out plug that plugs directly into a standard electrical outlet. (The optional CB-2L WE charger uses a plug-in cord.) Insert the battery with its arrow facing in the same direction as the one in the charger's battery receptacle and plug in the charger. An orange CHARGE light will verify that the battery has been properly inserted and that charging is taking place. When charging is complete (about 2 hours and 20 minutes for a fully discharged battery), the green FULL light will come on, indicating that the battery is completely charged. (Canon cautions not to charge the battery for longer than 24 continuous hours. This may damage it.)

To install the battery, slide the battery all the way in with the Canon logo facing upwards, and the arrow pointing in the same direction as the white arrow in the compartment until the orange battery retainer tab clicks in place.

A great thing about digital cameras, in addition to seeing the picture on the LCD, is the reusability of memory cards. You never have to worry about "burning costly film" or running out. You can shoot as many images as you want and download them later, then reformat and reuse the card.

The Memory Card: The Canon G10 accepts SD/SDHC Memory Cards, MultiMediaCards, MMC Plus Cards, and HC MMC Plus Cards. These newer, physically smaller cards used in the G10 were designed to make compact cameras a reality. Flash memory has the capacity to reliably store large amounts of data. Memory cards are durable, reusable, and storage capacity has greatly increased while prices have come down dramatically in the past few years. We recommend you pick up a couple of cards so that you have a spare, if necessary.

Insert the memory card in the slot with its contacts facing upward (toward the back of the camera). Confirm that the write protect tab (on SD and SDHC cards) is unlocked, and check any card for proper orientation before you press it all the way into locking position. Once you are finished inserting the memory card, close the battery/card compartment by

pressing the cover downwards against the bottom of the camera, and to the left until in locks in place with a click.

To remove the memory card, press it in all the way against the spring tension, then release your finger pressure and it will pop out.

It is recommended that you format a new memory card, or one from which you want to erase all images and data. Please note that this initializing process erases all data including protected images and sound files.

To format a memory card, turn the camera on, press the **MENU** button, use the four-way controller to select the Setup Menu 🛠 , then scroll to [Format] and press the 🔘 button. Use the right-left arrow buttons to select [OK], and press the 🔘 button.

Set the Date, Time, and Language
The first time you power up the G10 by pressing the **ON/OFF** button, directly behind the shutter release on the top of the camera, [Set Date/Time] will automatically appear on the LCD. To select the month, day, time, year, and the display order, use the four-way controller.

• Press the left/right controller keys to select an option—it will appear highlighted.

• Press the up/down controller keys to set the value for this option.

You can also select the value by turning the textured Control dial located around the four-way controller. To set your selected date, time, etc., press the 🔘 button.

The date and time can be changed at any time by first pressing the **MENU** button, then using the left/right controller keys to select the Setup Menu 🛠 , and then using the up/down controller keys to select [Date/Time]. To execute the new settings press the 🔘 button.

26

Note: A rechargeable lithium backup battery is built into the G10 to provide the power needed to save settings such as date and time, even when the main battery is removed from the camera. Inserting a charged battery or plugging the camera in using the (separately sold) AC adapter will automatically recharge the backup battery even if the camera is turned off. However, date/time settings may be lost if the main battery has been removed for about three weeks. If this happens, reset your date/time settings as described above.

Set the Language

To change the language displayed in LCD screen menus and messages, press the ▶ button. Now hold down the ⬢ button and simultaneously press the **MENU** button to display the language screen. Use the four-way controller or Control dial to select a language. Press the ⬢ button to execute your language setting.

Shooting Still Images in AUTO Mode

With a charged battery and formatted memory card inserted, press the **ON/OFF** button to activate the start-up sound and image display on the LCD screen. Select a shooting mode using the Mode dial on top of the camera—in this case set it to **AUTO**, the basic mode providing fully automatic focus and exposure. Aim the camera at the subject and compose the picture using the LCD screen and/or optical viewfinder.

Note: Pressing the ⬢ button, on the back of the camera in the upper right corner, while turning on the power, will silence all camera sounds. You can change the sound settings by going to [Mute] in the Set up Menu ⬚ . See page 87.

To take the picture, press the two-stage shutter button half way in to its focus position. When the autofocus system achieves proper focus, the camera beeps twice, and the indicator lights on the right side of the finder eyepiece light green (orange when the flash fires). Now press the shutter button fully (all the way in) to take the shot, and you will

After you take a picture, you can review it immediately on the camera's LCD. The Powershot G10 even offers a histogram for judging the exposure. Photo © Jeff Wignall.

hear the shutter operate. Immediately after shooting, the indicator light will blink green while the image file is being recorded, and the picture you've just taken will appear on the LCD screen (see page 80 for additional information on Rec. Review options).

Note: You can shoot another picture by pressing the shutter button again, even when a captured image is being displayed. If you hold the shutter button down after taking a shot, the image will continue to display.

Proper handholding technique really does make a difference in producing sharp images. Photo © Kevin Kopp.

SHOOTING TIP—IMAGE SHARPNESS: It is essential to hold the camera steady during the exposure. Just a slight movement of the camera while the shutter fires may result in blurry pictures, even when the camera's IS (image stabilization) system is activated. Also, to ensure that those parts of the picture you wish to be sharply rendered are in focus, be sure to place these critical areas in the central autofocus area frame on the LCD as you press the shutter release partway in to the focus position. Now maintain finger pressure to keep the shutter release partway depressed and the point of focus will be held as you recompose, brace yourself, hold your breath, and take the shot (also see AF Lock on page 129).

Viewing Still Photographs

After the initial image review, you can view recorded images on the LCD by pressing the ▶ button. It is not necessary to turn the camera on with the **ON/OFF** button. The last image recorded will be displayed and you can scroll through the images on the card using the left/right controller keys. The images will advance more quickly if you keep either of these keys depressed, but they will appear coarse (low resolution) as they advance. Alternatively, you can scroll very quickly through the recorded images by using the Control dial—the images will be shown in thumbnail format until you stop turning the dial, at which point the selected image will be displayed full size after about a second.

Note: In the Play Menu ▶ you can set [Resume] to display the shot last seen (the default setting) or the last one shot. If [Last seen] is selected, the last image you viewed will be displayed.

Erasing Images

To erase an image, press the ▶ button, use the left/right controller keys or the Control dial to select the image you wish to delete, and press the 🗑 button located on the back of the camera above and to the left of the Control dial. Use the left/right controller keys to highlight [Erase] or [Cancel] and press 🔘 . Exercise caution when erasing since erased images cannot be recovered.

Printing

To connect the camera to a direct print compatible printer, open the terminal cover on the right side of the camera body and insert the supplied interface cable all the way into the terminal, and plug the other end of the cable into the printer. Turn the printer on, and press the camera's ▶ button to turn on the power. The camera's 🖶 button near the upper left corner of the LCD screen will now light up blue. Using the left/right controller keys while viewing the LCD, select an image to print, and press the 🖶 button. The blue light will blink and printing will start. After you finish printing, turn off the camera and printer, and disconnect the interface cable.

30

View the photos in Playback mode that you've recorded to your memory card. You can erase the ones that you don't want and print those that you select directly from the camera without downloading to a computer.

Note: The G10 uses the standard PictBridge protocol, so you can use it with any other brand of PictBridge-compliant printers as well as Canon. You can imprint the date while printing using the camera's Digital Print Order Format (DPOF) feature, by setting the [Date] option to [On] in the Print Menu 🖺 (see page 116)..

Making a print list: To add images directly to a printing list, press the 🖨 button immediately after shooting or playing back an image. This allows easy printing of the selected still images when the camera is connected to a printer. Use the up/down controller keys to select the number of print copies for the selected image, use the left/right controller keys to select [Add.], and press the 🔘 button to save this setting. To remove images from the print list, press the 🖨 button again, use the left/right arrow buttons to select [Remove] and press the 🔘 button.

Printing images in the print list: Connect the camera to the printer with the interface cable as described above, turn the camera on, and, from the Print Menu ⊞ , use the up/down arrows to select [Print now]. Press the ⊛ button to start printing.

Note: The above is based on using Canon Selphy ES or CP series printers. Some details may not apply to other brands.

Shooting Movies using 🎬 Standard Mode

Press the ON/OFF button to turn the camera on, set the Mode dial to 🎬 , aim the camera at the subject, press the shutter button halfway to focus, and then press it all the way in to shoot.

Note: While the camera is focusing, it beeps twice and the indicator light turns green; when proper focus and exposure have been automatically set, it turns white. Do not touch the microphone while recording. Also, any sound made by buttons and other controls while shooting will be recorded in the movie.

Press the shutter release fully again to stop movie recording. The indicator will blink green as the data is recorded onto the memory card. Movie recording will stop automatically when the maximum recording time has elapsed or if the memory card is full. Maximum clip size is 4GB, but recording will stop after one hour even before the card fills up. Whether the recording stops after one hour or after the file reaches a certain size depends on memory card capacity and data write speed.

Viewing movies: To view a movie that has been recorded on the installed memory card, press the ▶ button, use the left/right controller keys or Control dial to select a movie file, and press the ⊛ button. Now use the left/right arrow buttons to select Play ▶ , press the ⊛ button and the movie will play on the LCD screen. You can adjust the playback volume using the up/down arrow buttons.

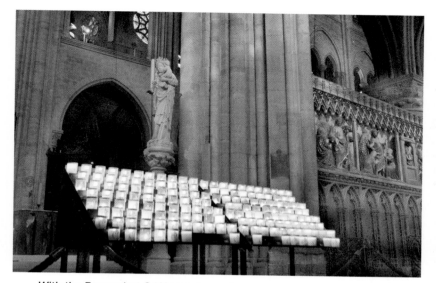

With the Powershot G10's movie mode you can capture the flickering of the candles at Notre Dame Cathedral and other travel memories. Just make sure you have a large capacity memory card for shooting videos. Photo © Jeff Wignall.

Downloading Images to a Computer

To download pictures, you will need the camera, a computer, the Canon Digital Camera Solution Disk, and the interface cable supplied with the camera.

Installing the software (Windows): Insert the Canon Digital Camera Solution Disk into the computer's CD-ROM drive, click [Easy Installation], and follow the onscreen prompts to install the software. Click the [Restart] or [Finish] button that appears on the screen, and remove the CD-ROM when the normal desktop screen appears.

Installing the software (Macintosh): After inserting the Canon Digital Camera Solution Disk, double-click on the [CD icon] that appears on the desktop. When the installer panel appears, click [Install] and follow the onscreen instructions.

Connecting the camera to a computer: Open the camera's terminal cover (on the right-hand side), insert the interface cable all the way into the terminal, and connect the other end to the computer's USB port.

Preparing to download images to the camera-connected computer: Press the ▶ button to turn on the camera. On a Windows-based system, select [Canon CameraWindow] and click [OK]. If the window does not appear, go to Start Menu>Programs>Canon Utilities>CameraWindow. On a Macintosh system, click the [CameraWindow] icon on the Dock that appears when you establish a connection.

Downloading images using the camera (Direct Transfer) after installing the software: Confirm that the Direct Transfer menu is displayed on the camera's LCD screen (the 🖷〜 button will light up blue). Press the MENU button if the Direct Transfer menu fails to appear. Press the 🖷〜 button to begin transferring images. You can also use the following options in the Direct Transfer menu to download specific categories of images:

All Images	Transfers all images to computer
New Images	Transfers only images not previously transferred
DPOF Trans. Images	Transfers only images with DPOF settings
Select & Transfer	Transfers single images as you view them
Wallpaper	Transfers single images as you view them to the computer as the desktop background

Use the up/down controller keys to select any of the categories listed in the table above. As the images are downloaded, the 🖷〜 button will blink blue. The display will return to the Direct Transfer menu when the download is complete. To cancel a download in progress, press the 🔘 button.

Note: Only JPEG images can be downloaded as wallpaper. The option selected with the 🖷〜 button is retained even after the camera is turned off, and will be in effect the next time the Direct Transfer menu is displayed.

When the day is done it is time to download images to your computer. Most photographers prefer to do this with a USB card reader because all you have to do is connect the card reader to your computer and insert the memory card into the reader. Photo © Jeff Wignall.

Basic Features and Operations

The Optical Viewfinder

The direct vision optical zoom viewfinder built into the G10 is useful when shooting in extremely dark or very bright light when the LCD screen may be hard to see. Holding the camera up to your eye to see through the viewfinder also provides a firmer, less shake-prone support than holding the camera out with your arms to preview with the LCD screen, especially when shooting at slow shutter speeds or in dim light without flash. Turning off the LCD often by pressing the ⊙(DISP) button (on the back of the camera next to the lower right corner of the LCD screen) will also help to conserve battery power while shooting. The viewfinder can be adjusted to suit your eyesight (-3.0 to +1.0 diopters) by turning the diopter adjustment dial to the left of the viewfinder eyepiece until detailed objects at infinity in the viewfinder appear in sharp focus without your glasses on. This compensation will allow you to look through the viewfinder without your glasses being in the way. However, if you wear your glasses when shooting, adjust the diopter control while wearing them.

Hint: Parallax error occurs with viewfinder cameras because the viewfinder sees a slightly different view than the lens. When you look at the captured image, the framing may not be the same as what you saw in the optical viewfinder. This is most evident at close distances and not so critical when photographing subjects that are farther away. For accurate compositions at closer distances, or anytime framing is extremely critical, use the LCD screen.

◁ *The large, bright LCD screen on the back of the G10 makes it easy to compose pictures and see how the image will appear before you push the shutter button. Photo © Kevin Kopp.*

Canon G10 – Front View

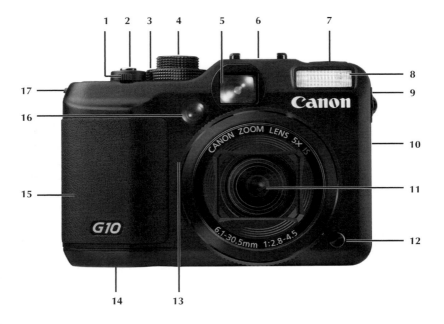

1. Zoom lever
2. Shutter release
3. ISO speed dial
4. Mode dial
5. Viewfinder front window
6. Hot shoe
7. Exposure compensation dial
8. Flash
9. Strap mount

10. Speaker
11. Zoom lens
12. Ring release button
13. Bayonet cover ring
14. Memory card/battery cover
15. Hand grip
16. AF assist/redeye reduction/self-timer lamp
17. Strap mount

Canon G10 – Rear View

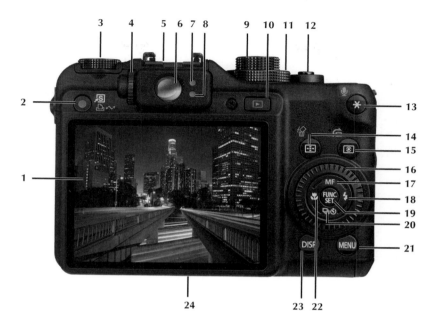

1. LCD screen
2. 🖪 Shortcut button /
 🖶∼ print/share button
3. Exposure compensation dial
4. Viewfinder diopter
 adjustment dial
5. Hot shoe
6. Viewfinder eyepiece
7. Shooting/recording/
 camera shake indicator
8. Macro/manual focus/
 AF lock indicator
9. Mode dial
10. Playback button
11. ISO speed dial
12. Shutter release
13. ✳ AE/ FE lock /
 🎤 Microphone button
14. ⊞ AF frame selector /
 🗑 Image erase button
15. 🔳 Metering mode
 button/ 🔍 jump button
16. Control dial
17. MF Manual focus /
 up controller key
18. 🔱 Flash mode /
 right controller key
19. ⓔ FUNC./SET button
20. 🕮 Continuous shooting
 button / 🕙 self-timer
 button / down controller key
21. MENU button
22. 🌷 Macro button /
 left controller key
23. ⓔ DISP. (display) button
24. Tripod socket

39

Canon G10 – Top View

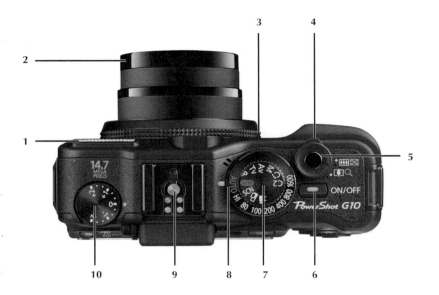

1. Built-in flash
2. Zoom lens
3. Bayonet cover ring
4. Zoom lever /
 - ▥ wide angle/
 - ◌ magnify
 - ◖♦◗ telephoto/
 - ▦ index

5. Shutter release
6. Power (ON/OFF) button
7. Mode dial
8. ISO speed dial
9. Hot shoe
10. Exposure compensation dial

LCD Screen – Shooting Mode

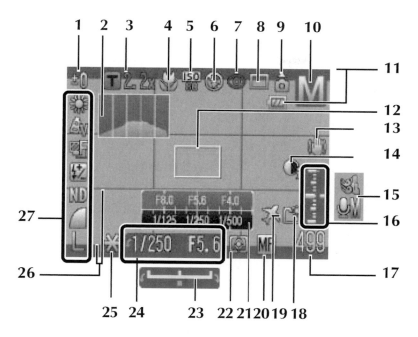

1. Exposure compensation
 -2...+2
2. Histogram
3. Digital teleconverter [T]
 1.7x-2.2x
 Digital zoom factor
 Safety zoom
4. Macro
5. ISO speed
6. Flash
7. Red-eye correction
8. Drive mode
9. Auto-rotate
10. Shooting mode
11. Battery charge indicator
12. Spot AE point frame
 AF frame

13. Image stabilization mode
14. i-Contrast
15. Audio
16. Exposure level indicator
17. Shots remaining
 Elapsed time
18. Create folder
19. Time zone
20. Manual focus
21. Av/Tv bar
22. Metering mode
23. Exposure shift bar
24. Shutter speed and
 aperture value
25. AF/FE lock
26. Display overlays
27. FUNC. Menu items

41

LCD Screen – Playback Mode

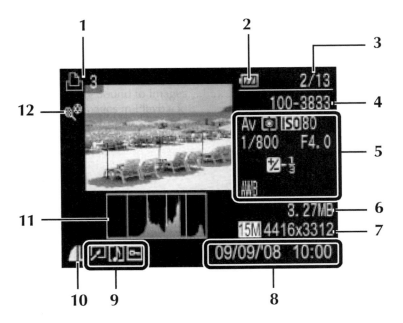

1. Print list ·
2. Battery charge indicator
3. Displayed image number/
 total number of images
4. Folder number – file number
5. Shooting information
6. File size
7. Resolution (recording pixels)
 Movie length
8. Shooting date/time
9. i-Contrast
 Red-eye correction
 Trimming
 Resized image
 My colors
 Protection status
 Sound memo

10. Compression setting
 Resolution
 Movie mode
11. Histogram
12. Auto category
 My category

The LCD Screen

The LCD screen shows 100 percent of the picture as seen by the lens. It provides a bright, high-resolution image with a programmable range of brightness settings. It can be set to display information about the camera modes and settings in use before or after shooting and offers magnified viewing options for image evaluation. It also provides tools to evaluate exposure, such as the histogram.

Information Display
Press the (DISP) button to cycle through three basic display settings while previewing a scene on the LCD before shooting. The information seen in each of these is variable, depending on the Shooting mode and on the settings selected in the [Custom Display . . .] item of the 📷 Menu (see page 83). You can alternate between a blank, darkened LCD screen and Display 1 and Display 2. These displays can be set to show various shooting information, like shutter speed, aperture, a histogram, and more in the [Custom Display...] item in the 📷 Menu.

Playback Mode
To review images after recording, press the ▶ button. Then press (DISP) as needed to cycle through four display options: No Information (image only), Standard Playback Display (file number, date, file size and type, battery icon), Detailed Display (file number, exposure and metering mode, exposure data, exposure compensation, histogram, date, battery icon, etc.), and Focus Check (which displays selectable magnified images, including those of faces detected by Face Detection). (For more on Playback, see pages 159 – 174.)

Screen Brightness
The brightness level of the LCD screen can be set or changed in the Set up Menu 🔧 (see page 89). A faster alternative is to activate the quick-bright LCD function: Hold down (DISP) for one second or longer and the LCD image will be displayed at maximum brightness regardless of the menu setting for brightness. To restore the previous bright-

ness setting, hold ⓘ(DISP) for more than one second again. The next time the LCD screen is activated it will be at the brightness setting selected in the 🔳 Menu.

Night View
When shooting in low light, the camera's automatic Night View feature will display the subject brightly on the LCD to facilitate composition. This feature cannot be turned off. When Night View is active, the tonal range of the image shown on the LCD will differ from that of the actual recorded image. However, noise or jagged movement shown on the LCD will have no effect on the image recorded by the camera.

LED Indicators

There are two small LED lights situated on the back of the camera to the immediate right of the viewfinder. These give you information about the camera's readiness to shoot an image.

Upper LED
- **Steady green:** Informs you that the camera is ready to shoot (you will also hear two quick beeps).

- **Blinking green:** The camera is in the process of recording the image, erasing it, or transferring the image to a computer (and is therefore not ready to shoot). Never shake, jolt, or turn off the camera, or open the memory card/battery cover while the upper indicator blinks green or the image data may be corrupted.

- **Steady orange:** The flash is active and the camera is ready to shoot.

- **Blinking orange:** The camera will shoot, but this is a camera shake warning, meaning the resulting picture may be blurry unless you select a faster shutter speed, activate Image Stabilization, increase the ISO, or use a tripod.

Changing your camera's ISO lets you quickly achieve the best light sensitivity for various shooting situations. For daytime shots with plenty of light, low ISOs are best because they create less noise in the image. Photo © Kevin Kopp.

Lower LED

- **Steady yellow:** The camera is set to Macro mode, for manual focus **MF** , or shooting with AF lock.

- **Blinking yellow:** The camera is having difficulty focusing (it will emit one beep).

ISO

While digital camera sensors have a fixed sensitivity, camera electronics allow you to change the ISO as needed. Increased sensitivity is accomplished by amplifying the signal or increasing the gain, but higher ISOs do come at a cost in the form of increased noise on the image. Digital camera

makers use ISO settings that are equivalent to the values used for film, so if you are used to working with film ISOs, not much has changed.

Setting the ISO

When you select an appropriate ISO speed, the LED to the left of the dial lights orange. This lamp turns off if you select an ISO speed that cannot be used and the camera automatically defaults to ISO AUTO (or ISO 80 in **M** Shooting mode). At ISO AUTO or HI, the camera calculates and sets the optimal ISO based on the ambient light level. The ISO AUTO setting ensures good image quality under changing light conditions. At ISO HI, the camera detects motion and uses this information as well as light level data to set the optimum ISO speed. This program favors even faster shutter speeds and higher ISO settings than the AUTO to reduce the image-blurring effects of camera shake, and is recommended when shooting action subjects.

Image Quality

Low ISO settings such as 80 and 100 usually provide maximum image quality, while intermediate speeds such as 200 and 400 provide greater shooting flexibility (e.g. allowing for a greater range of exposure settings and slightly lower light levels) with little adverse effect on image quality. For optimum image quality, use the lowest ISO speed possible (because digital noise increases with higher ISOs). However, there are times that a higher ISO speed will make the difference in getting or not getting a shot. In this case, ISO settings in the 800–1600 range allow pictures to be taken handheld without flash in dim light or at night, but there will likely be a noticeable decrease in image quality caused by digital noise.

Shutter Speed

Higher ISO settings allow the use of faster shutter speeds. This can be extremely useful when handholding your camera, especially with the telephoto end of the zoom range. Faster shutter speeds will help to produce a sharper picture and will freeze action better.

Flash Range

With any given flash unit, whether built-in or accessory, higher ISO settings will provide more reach for the flash. Lower ISO settings usually make fill-flash easier to use in bright conditions because these aren't as easily influenced by ambient light.

Image Stabilization (IS)

The optical image stabilization (IS) system built into the G10 shifts elements within the lens to minimize the image-blurring effects of camera shake. This is particularly important when shooting distant objects at high magnification at the telephoto end of the zoom lens, or when shooting at slow shutter speeds in dark conditions without flash. Use the menu system to select or change the IS settings (see pages 83).

Note: When using the teleconverter TC-DC58D, icons other than [Off] appear on the LCD with a T subscript to indicate that the teleconverter is in use. If camera shake is too strong or the shutter speed in use is too slow, the movement may not be fully corrected by the IS system. Set the ISO Dial to Auto or Hi to enable a faster shutter speed, or use a tripod. Turn the IS setting off when using a tripod.

Camera Shake Warning & Auto ISO Shift

The camera shake warning 🔲 appears on the LCD screen during shooting when the shutter speed is too slow to produce a sharp, handheld image. This is usually due to low lighting conditions or the use of a long focal length, especially with an attached teleconverter. Even when image stabilization is activated, there will be times when it can't compensate enough and you will still see the camera shake warning.

When you see this warning, there is a quick solution for reducing camera shake called Auto ISO Shift. The camera can be set so it overrides the primary function of The Short-cut button 🔳 and initiates Auto ISO Shift when 🔲 appears; this increases the ISO and allows the camera to

automatically select a faster shutter speed, thereby minimizing the effects of camera shake. However, depending on the darkness of the shooting conditions, you still may see the warning icon even if the ISO speed is increased.

Use the 🔲 Menu to activate [Auto ISO Shift] so the ⚡S button will automatically increase the ISO. Once ⚡S is enabled in this manner, it will glow blue when the shutter button is pressed halfway and 🔘 flashes (note: this only occurs in **AUTO**, **P**, and **Av** Shooting modes). Press the blue ⚡S button to initiate Auto ISO Shift; you will see the ISO and shutter speed automatically adjust on the LCD screen (if you are in Information View Display). Press the shutter release all the way in to take the shot.

Note: Auto ISO Shift cannot be activated when the ISO Dial is set to Hi, 800, or 1600. If the AE Lock is activated after the ISO setting has been raised, the ⚡S turns off and the ISO will not return to its original setting even if you release finger pressure on the shutter button.

The Mode dial

Traditional analog dials on top of the G10 allow for easy, intuitive setting of exposure compensation (+/-2 Ev), ISO (including Auto and Hi 3200 settings), and a range of shooting modes (sometimes known as exposure modes), including AUTO, Manual, P, Tv, Av, two Custom settings, Movie, Stitch Assistant (for panoramas), and Scene modes. Other modes and settings are accessed via the controls on the four-way controller, located on the back of the camera to the right of the LCD.

The Mode dial, representing all of the Shooting modes, is divided into two parts, the Creative Zone and the Image zone. P, Tv, Av, M, C1, and C2 modes comprise the Creative Zone. In these modes, you can select among manual, aperture, and shutter speed priority settings to suit your shooting goals and

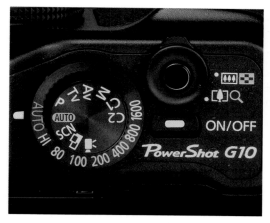

The G10 has given photographers something that they really like—traditional analog dials for setting major functions such as the shooting mode and ISO.

express your creative intent. The SCN modes, Stitch Assist mode, and Movie mode comprise the Image Zone. **AUTO** mode is somewhat orphaned—it does not belong to either group. In **AUTO** mode or any of the SCN modes, the camera automatically selects aperture and shutter speed settings based on the light level. We'll review the details of each mode below.

AUTO AUTO Mode

The camera chooses all settings based on the scene it is interpreting; the photographer cannot make adjustments. The camera will choose the aperture, shutter speed, ISO, WB, and more. This is the most basic of all the shooting modes in that you simply set **AUTO** on the Mode dial, point the camera, and take the picture.

P Program AE Mode

When the Mode dial is set to **P** , the camera automatically sets both the aperture and shutter speed to provide a correct exposure based on the brightness of the scene. However, the **P** mode offers more flexibility than the **AUTO** mode. For example, unlike **AUTO** , you can set the ISO speed, exposure compensation, and white balance, and you can shoot RAW as well as JPEG images (for more on Program AE mode, see pages 142 – 144).

Tv Shutter Speed Mode

This mode is often referred to as Shutter priority mode. When the Mode dial is set to **Tv** , you choose the shutter speed and the camera automatically sets a corresponding aperture that will provide a correct exposure based on the scene brightness (for more on Shutter Speed mode, see page 144).

Av Aperture Mode

This is commonly known as Aperture priority mode. When the Mode dial is set to **Av** , you set the aperture value and the camera automatically sets the shutter speed to provide a correct exposure based on the scene brightness (for more on Aperture Mode, see pages 145 – 146).

M Manual Mode

Setting the Mode dial to **M** allows you to manually set both the aperture and shutter speed to control the exposure (for more on Manual Mode, see pages 146 – 147).

C1 and C2 (Saving Custom Settings)

The C1 and C2 settings allow you to save frequently used shooting modes and a variety of shooting settings for quick and easy access. The basic procedure is to select a shooting mode (**P** , **Tv** , **Av** , or **M**) and select the settings you wish to save in that mode. You can save these settings in the 🔘 Menu (see page 86).

SCN SCN Modes

Choosing one of the Scene modes sets the camera to use pre-programmed settings for specific types of scenes or subjects, like portraits or landscapes. To select an appropriate mode, turn the Mode dial atop the camera to **SCN**, turn the camera on, and note the icon that appears in the upper right-hand corner of the LCD screen with a green, curved double-ended arrow symbol below it. The green arrow symbol indicates that you turn the Control dial to select the **SCN** mode of your choice. Once you see the correct magnified icon and identifying description for the specific mode you wish to use, stop turning the dial. The selected icon will

This picture of a mural on the side of a large urban building was stitched together from multiple photographs. Photo © Kevin Kopp.

momentarily appear in the upper right-hand corner of the screen. For full information on using the **SCN** modes, see pages 148 – 149.

⊡ Panoramic Images and Stitch Assist

Stitch Assist can be used to shoot overlapping images that can later be merged (or stitched) into a single photo on a computer. The overlapping seams of these adjacent images are joined to create a seamless panoramic image similar to those captured by a special panoramic camera.

To select Stitch Assist, set the Mode dial to ⊡ . Turn the Control dial to select a shooting direction—there are five options: left-to-right horizontally, right-to-left horizontally, bottom-to-top vertically, top-to-bottom vertically, and clockwise starting at the top left-hand corner. The choice you select is clearly indicated by an arrow and graphics on the screen. Once you select your option, shoot the first frame of the sequence (this locks in the exposure and white balance for each subsequent shot), compose the second image so

51

that it overlaps a portion of the first image and shoot; then repeat this process for up to 26 images (except in clockwise option, where the number is limited to four images). Press the ⓕ button after the last shot.

Note: You can use the four-way controller to return to a previously recorded image and retake the shot (when shooting clockwise you can retake the entire sequence). Minor discrepancies in the overlapping portions can be corrected when the images are stitched together. You cannot display the images on a TV when shooting in Stitch Assist mode. Use PhotoStitch, a software program supplied with your G10 on the Solution Disk CD, to merge the images on a computer.

🎞 Movie Shooting

Set the Mode dial to 🎞 , turn the Control dial to select a movie mode—Standard (🎞), Color Accent (📷) , or Color Swap (📷)—and press the shutter release fully to record video with sound. In 📷 mode, one single selected color remains and the rest of the colors are changed to black-and-white. In 📷 mode, you can change one specified color into a different color.

Note: The maximum size for a single movie is 4GB. Actual maximum recording time depends on memory capacity of your memory card—shooting will continue on cards smaller than 4GB until the memory is full. Digital zoom is available in Standard mode (see page 76 for details). Try not to press buttons or touch the microphone while recording movies, as the sound will also be recorded. Focus and zoom settings are fixed once recording begins.

Changing Movie Recording Pixels (video resolution): With the Mode dial set to 🎞 , press ⓕ , use the up/down four-way controller keys to select 640 for VGA movies (640 x 480 pixels at 30 frames/second) and the right/left controller keys to select 320 for movies at 320 x 240 pixels at 30 frames/second. Then press ⓕ to save and activate your selection.

The Control Dial

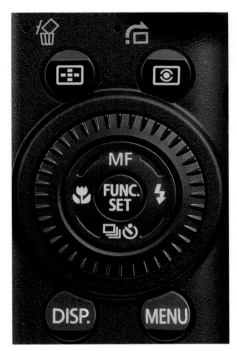

Use the Control dial to easily navigate through menus and to change settings such as aperture and shutter speed.

Located on the back of the camera's right side, the large Control dial offers a quick and convenient way to scroll through images, settings, menus, and icons as they are displayed on the LCD screen. Turning this dial clockwise is equivalent to pressing the right controller key, and turning it counterclockwise is the same as pressing the left controller key. You can also use the Control dial to select the shutter speed in **Tv** mode, the aperture value in **Av** mode, and either the aperture or shutter speed setting in **M** mode.

Recording photos as compressed JPEGs can allow you to send small-sized image files as email attachments without a lot of processing and resizing.

Menus Overview

Many of the settings for shooting, printing, and playing back your images, as well as such items as date/time and audio indicators, are set using the FUNC. menu or the menu tabs for Rec. (📷) Play (▶), Print (🖴), Set Up (🔧), My Camera (📷), and My Menus (★). For a more detailed look at all menu options and how to set them, see pages 61 – 119.

Playback

The Playback button ▶ (on back of the camera above the top-right corner of the LCD screen) can be used to display recorded images. To display recorded images with the lens retracted, press the ▶ button with the camera turned off. To display recorded images with the lens extended, first turn the camera on by pressing the ON/OFF button, then press the ▶ button. To turn the playback image off with the lens extended in Shooting mode and return to the shooting screen, press the shutter release half way.

File Formats

There is a lot of discussion these days about file types. While some people are staunch proponents of one format over others, in truth, all file formats serve various purposes and needs.

JPEG (Joint Photographic Experts Group)

JPEG is an international standard for compression technology that provides a small file with superb detail. While technically not a format (but generally spoken of as one), JPEG is the most universally used file type. Higher JPEG compression settings create smaller files that fit easily on the memory card and upload more quickly to the Internet, although important data may be lost if JPEGs are overly compressed, and image quality can suffer. This is because JPEG is a "lossy" standard, meaning data is discarded as the file is compressed, then is rebuilt when the file is reopened. This data is more easily rebuilt when a low-compression level (high quality level) has been set in the camera. JPEGs are a practical choice for photographers, but they should be set for the least amount of compression most of the time.

Caution: Don't do image processing in the computer and save and resave the photo as a JPEG! This "lossy" file type loses image data each time it is resaved. When you open a JPEG file in your image-processing program, you should save it in another format, such as TIFF or EPS, before you start editing.

RAW

This file type applies minimal in-camera processing or compression to the data, interpreting the image directly as it comes from the sensor. RAW offers more color data and larger files with its 16-bit file compared to the 8-bits of JPEG. This increased data can allow for broader adjustments and changes to the image file while producing fewer problems in terms of image degradation than JPEGs, though adjustments to RAW files must take place in the computer with special software before they can be ready to print. Various programs for this purpose include Canon's Digital Photo Professional. After processing, you can convert RAW files to other suitable types, such as JPEG or TIFF. RAW files are proprietary for each camera manufacturer, so you'll notice that your Canon RAW files end in .CR2 while RAW files from another camera brand will have a different suffix.

The merits of JPEG vs. RAW have long been fodder for debate. Many digital photographers have the notion that JPEG is for amateur use and RAW is for pros. That is not really true. Both file types are capable of producing excellent images. JPEGs are processed inside the camera for optimum image quality and are compressed to allow a larger number of images to be stored on the memory card. They can also be printed directly from the camera. RAW files, on the other hand, provide much more control and flexibility for processing the image in the computer after it is downloaded.

What is important is your type of photography and your way of working. Generally, I recommend RAW or Large/Superfine JPEG files. Though they require more memory, these files give you the most options for processing and printing your photos. You can always reduce the file size during image processing in the computer. If you're on the fence, you can set ☒ + ◢L in the ⊡ Menu until you figure out which format you prefer.

It is usually the best strategy to record using the highest resolution for photos in which you are concerned about showing the clearest detail and most vibrant colors. Photo © Kevin Kopp.

Quality and Resolution

The G10 can be set to capture image files as JPEG, RAW, or both simultaneously (JPEG+RAW). In addition, you can change the quantity of recording pixels (resolution), as well as the level of JPEG compression (quality) using the FUNC. Menu.

Recording Pixels

Often also known as Image Size, this setting describes the resolution of the image file. It allows you to select the quantity of pixels the sensor will use to record a photo. (The maximum number of effective pixels for the G10 is approximately 14.7 million, or 15 megapixels.) Higher resolution usually produces finer detail in pictures than a lower resolution setting, and insures the ability to make larger prints without pixilation. It also gives you more flexibility for cropping your images.

The G10 offers a variety of options—see page 70 for details on setting Recording Pixels.

- **L** **Large:** 4416 x 3312 pixels (approximately 14.7MP). This selection offers the greatest number of opportunities for cropping and processing JPEG images without reducing quality, but it also consumes the most memory. It can easily produce good-quality prints of 17 x 24 inches (425 x 600 mm).

- **M1** **Medium 1:** 3456 x 2592 pixels (approximately 9MP). This will use less memory than Large but is still a high enough resolution to allow significant cropping and produce good-quality prints of 11 x 17 inches (295 x 425 mm).

- **M2** **Medium 2:** 2592 x 1944 pixels (approximately 5MP).

- **M3** **Medium 3:** 1600 x 1200 pixels (approximately 2MP).

- **S** **Small:** 640 x 480 pixels (approximately 0.3MP). This is a good resolution to use if you want to email images or upload them as illustrations to a website.

- **W** **Widescreen:** 4416 x 2480 pixels (approximately 11MP). This alters the aspect ratio from 3:2 to 16:9, cropping a portion of the image from the longer sides of the full-dimensioned file.

- **RAW** **RAW:** 4416 x 3312 (approximately 14.7MP). RAW files are always full resolution without compression. Because they have very little, if any, processing applied by the camera, they usually offer the highest quality images with a great amount of latitude for processing image attributes in the computer.

- **RAW** + **◢L** **RAW + JPEG:** Record an image as a RAW file and a Large, Fine JPEG at the same time.

Note: To activate recording in both RAW and JPEG simulta-
neously, the file size must be set to **RAW** in the FUNC.
Menu. If any other setting is used, you will only record
JPEG images even if **RAW** + **◢L** is set to [On] in the
 ◉ Menu.

Compression

As noted previously, JPEG image files are compressed. This
setting in the FUNC. Menu (see page 69) allows you to con-
trol the degree of compression, producing image files with
various sizes (in terms of megabytes—MB) and levels of qual-
ity. As greater levels of compression are applied, the files are
made smaller so that more of them can be stored in memory,
either on your SD card or on your computer. However, greater
compression leads to lower quality photos and the inability to
make large prints without artifacts and softness.

- **S** **Superfine:** The lowest level of compression; high-
 est quality photos; fewest quantity of images can be
 stored.

- **◻** **Fine:** Medium amount of compression; high qual-
 ity photos.

- **◻** **Normal:** Highest level of compression; least qual-
 ity; requires the least amount of storage space.

Note: You cannot set Compression when RAW **RAW** is
selected for Recording Pixels, since the camera will not
compress or otherwise process RAW files.

When recording JPEGs, it may be convenient to think of
the functions for Compression and Recording Pixels in com-
bination, producing image files on a continuum from **S**
and **L** (largest file size, highest resolution) to **◻** and
 S (smallest file size, lowest resolution). You have the
ability to produce a variety of different quality and size files,
depending on your needs.

The FUNC. Menu

You are no doubt familiar with menu systems, having used them to navigate among the different options available on your cell phone, DVR, portable music player, or some other electronic device. Menus have become commonplace, and they are an important characteristic of digital cameras. They are used to help you set and control many of the functions found in your G10.

The menu system in your PowerShot G10 is displayed on the LCD screen, which offers a large (3.0 inches, 7.6 cm), high-resolution (460,000 dots) screen (so the menus are easy to see). In fact, you will find two menu systems in this camera, differentiated by the method of access. First, in the FUNC. Menu, you will find a number of items that have an impact upon the shooting function, as well as upon some other camera settings. Apply the options within this menu by pressing the FUNC./SET button 🔘 found in the center of the Control dial—the large dial on the back of the camera. Second, use the MENU button (on the back of the camera in the lower right corner) to select an array of camera settings and controls found under two separate sets of menu tabs, one for the Shooting mode and one for the Playback mode— see pages 73 – 98 and 101 – 119 respectively for more detailed information.

◁ *The PowerShot G10's menu system offers an amazing amount of control over your photography. The FUNC. Menu lets you quickly and easily set such important functions as white balance, image quality, and resolution, among others. Photo © Kevin Kopp.*

Whenever your G10 is powered up, you will generally use the up (**MF**), down (⊒ ⏱), left (❀), and right (⚡) controller keys of the four-way controller to scroll to the various menu options. Press the ⊛ button to confirm your menu selection and/or exit the FUNC. Menu. All four keys of the four-way controller, plus the ⊛ button, are found on the Control dial.

Navigating the FUNC. Menu

The FUNC. Menu has a column of items on the left side of the LCD screen. Scroll up and down the column to highlight the function you want to adjust.

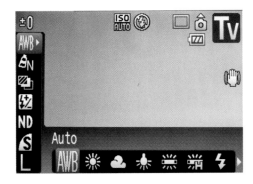

The FUNC. Menu contains a number of items that influence the look and quality of the images when you shoot pictures or record a video. You must first set the camera to be in the Shooting mode (one of the choices on the Mode dial on top of the camera), so that you are ready to take pictures or a movie. Press the ⊛ button to display the FUNC. Menu.

Note: Not all the items and their assorted options in the FUNC. Menu can be set in all Shooting modes. For example, only Auto white balance ▧ is available in 〔AUTO〕 Shooting mode, the multiple **SCN** modes, and the Movie mode ▣ . Since these modes are controlled by the camera, your ability to alter settings in them is limited. The Creative Zone choices in the Shooting mode—like P, A, S, and M—offer more opportunity to make choices about settings in the FUNC. Menu.

Late afternoon sunlight has a different color temperature than mid day sunlight, giving it a golden quality. Use the different white balance settings to take advantage of the way light changes throughout the day and under different lighting scenarios. Photo © Matt Paden.

When the menu displays in the LCD screen, scroll up or down in the left-hand column using the appropriate controller key until the item you want is highlighted. You will notice icons for sub-items, or various options, for the highlighted item displayed in a row along the bottom of the LCD. Scroll with the left/right controller keys along the row of options at the bottom until you highlight the selection you want, and confirm by pressing (FUNC. SET) .

The items in the FUNC. Menu are:

White Balance (WB)

Different sources of light have different color temperatures. This means that the same scene shot under mid day sun will look much different when illuminated by an incandescent lamp, a fluorescent light, stadium spots, or even the sun in the morning or late afternoon. Lower temperatures are warmer,

meaning they will have a more red or yellowish appearance than higher temperatures, which will look bluer. White balance is a digital photographic process that neutralizes these color casts, making the scene look more natural. See pages 149 – 151 for more information about white balance.

Setting the white balance to Daylight in the FUNC. Menu.

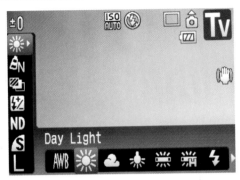

The item for white balance is always the top icon in the left column of the FUNC. Menu. There are a number of white balance options you can set on the G10 (see page 151 for more information about what each of these settings do).

- ▦ Auto
- ☀ Day Light
- ☁ Cloudy
- ☀ Tungsten
- ▦ Fluorescent
- ▦ Fluorescent H
- ⚡ Flash
- ▦ Underwater
- ▦ / ▦ Custom 1 and Custom 2

To create a Custom white balance, scroll to and select ▦ or ▦ . Find a white target (such as a piece of paper, a cloth, or a wall) and aim the camera at it, making sure the target fills the viewfinder or LCD screen. Press the (DISP) button and the camera will evaluate the required white balance. Then press the (FUNC SET) to set the Custom white balance.

The center frame will not display when digital zoom is in use or when the digital teleconverter icon is displayed. However, you can also use the optical viewfinder to take a Custom white balance reading.

Note: Custom 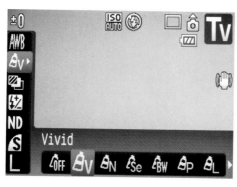 and 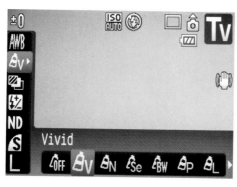 will stay at their respective settings, even if the camera is turned off, until you repeat the process to alter or modify them.

My Colors

Directly below the white balance item in the FUNC. Menu is My Colors. This feature permits you to change the look of a JPEG image when it is shot (or after it is recorded, see page 154 for additional information).

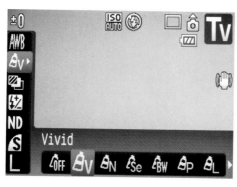

The My Colors selections sets in-camera processing, allowing you to alter colors and skin tones of JPEG photos.

- 🔲 Off
- 🔲 Vivid
- 🔲 Neutral
- 🔲 Sepia
- 🔲 B/W
- 🔲 Positive Film
- 🔲 Lighter Skin
- 🔲 Darker Skin
- 🔲 Vivid Blue
- 🔲 Vivid Green
- 🔲 Vivid Red
- 🔲 Custom Color: Adjust contrast, saturation, and sharpness levels, as well as color intensity.

To apply [Custom Color], highlight 🎨 and press the 🔘 button. A selection for [Contrast] will appear with a bar scale and four discrete increments. Scroll right to increase contrast, or left to decrease contrast. Then scroll up or down to change attributes; for example, changing from [Contrast] to [Saturation], or [Saturation] to [Sharpness], and to control the intensity of [Red], [Green], [Blue], or [Skin Tone], etc. Press 🔘 when you have made all the Custom Color changes that you intend.

Bracket

Bracketing is when a camera automatically records several still images at different settings in order to increase the probability of capturing the optimal photo. This item is the third from the top of the FUNC. Menu's left column (and does not apply to the Movie mode). The G10 can bracket both exposure and focus.

- 🔲 **Bracketing Off:** The camera will not bracket; only one image will be recorded when you press the shutter button. Use this setting to cancel either of the other two bracket settings.

- 🔲 **Autoexposure Bracketing (AEB):** The camera will automatically record three pictures at different exposures when you press the shutter button. The order of these images on your memory card will be: standard exposure (0); underexposure (–); overexposure (+). (See page 141 for more information on AEB.)

There is a range of exposure within which you can set the bracket levels. After scrolling to highlight 🔲 , press 🔘 to see a scale with a range for –2 to +2, with 0 representing the standard exposure value. Use the left/right controller keys to increase or decrease the range in exposure value (EV) by 1/3-stop increments. Press 🔘 to confirm the AEB range.

After highlighting AEB, press ⊙ to determine the difference in exposure value from shot to shot.

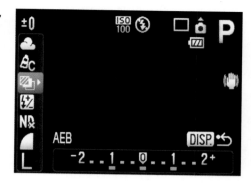

- 🖼️ **Focus Bracketing:** As with AEB, the camera will automatically take three photos when you press the shutter button, but this time it will bracket focus instead of exposure. See page 130 for additional information.

After highlighting 🖼️ , press ⊙ to see a horizontal scale with incremental marks. Use the left/right controller keys to lengthen (move toward increments at the outside of the scale) or shorten (toward middle of scale) the distance that will be in focus in front and behind the subject. Then press 🔘 to confirm the focus range increments you have selected. The next step is to press the Manual Focus **MF** button (the same as the up controller key) and rotate the Control dial. The subject will display in a magnified rectangular focus screen in the middle of the LCD. Continue to rotate the Control dial to adjust and refine sharpness, which sets the focus point. Press the shutter button to then record three images bracketed for focus.

Sometimes the default flash setting will over-expose areas close to the camera, or will not be strong enough to properly illuminate your subject. Adjust the intensity of the flash with the Flash exposure compensation function.

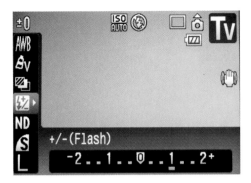

Flash Exposure Compensation

Below Bracketing in the FUNC. Menu is Flash exposure compensation. This item allows you to adjust the intensity of the built-in or external flash. Highlight ![icon] and a scale appears across the bottom of the LCD, ranging from –2 to +2 EV in increments of 1/3 stops. Scroll left or right to increase or decrease the output of the flash.

In order to utilize the 1/3-stop increments when recording in **Tv** (Shutter) or **Av** (Aperture) Shooting modes, you must first set [Auto] in the Rec. Menu (![icon]). Press MENU , scroll down from ![icon] to [Flash Control], press ![icon] and scroll to [Auto] in the [Flash Mode] option. If [Manual] is selected in [Flash Mode], the camera controls intensity with Flash Output, which offers only three total increments on a bar scale (minimum, medium, and maximum levels).

Note: You cannot set Flash exposure compensation in the Movie Shooting mode.

ND (Neutral Density) Filter

The next icon in the FUNC. column is ND. When activated, this item allows less light to pass to the sensor, permitting the use of slower shutter speeds on a bright day. (See page 153 for additional information.)

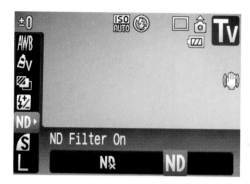

The Neutral Density Filter effect, when applied, is handy to use when photographing brightly lit scenes.

- 📷 **ND Off:** There is no effect on the photograph.
- 📷 **ND On:** Light from scene is reduced by three stops.

Compression

JPEG image files are compressed to different quality levels, producing different file sizes (in terms of megabytes—MB). With greater levels of compression, the files are made smaller and more can be stored in memory, either on your SD card or on your computer. However, greater compression leads to lower quality photos and the inability to make large prints without artifacts and softness.

- **S** **Superfine:** The lowest amount of compression is applied to a recorded JPEG.
- ◢ **Fine:** A medium amount of compression.
- ◢ **Normal:** The highest level of compression.

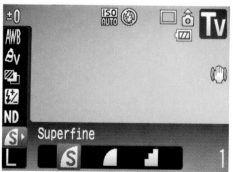

Compressing JPEG files allows you to record and store more images on your memory card, but it also can degrade the photograph.

The G10's ability to record RAW images is a welcome feature for photographers who enjoy controlling image processing in the computer. RAW offers more options for adjustment after the shot has been recorded, allowing you to alter color temperature and even, to a certain degree, the exposure of your photo. Photo © Matt Paden.

Recording Pixels

Often also known as Image Size, this item, which is at the bottom of the FUNC. column, describes the resolution of the image file. It allows you to select the quantity of pixels the sensor will use to record the photo. (The maximum number of effective pixels for the G10 is approximately 14.7 million, or 14.7 megapixels.) Higher resolution usually produces finer detail in pictures than a lower resolution setting, and insures the ability to make larger prints without pixilation.

- **Large:** 4416 x 3312 pixels (approx. 14.7MP). This selection offers the greatest number of opportunities for cropping and processing JPEG images without reducing quality, but it also consumes the most memory. It can easily produce good-quality prints of 17 x 24 inches (425 x 600 mm).

The number of pixels used to record your image has a big effect on the sharpness of details in a photo at larger print sizes.

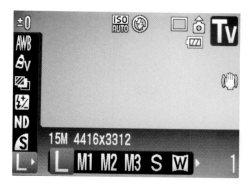

- 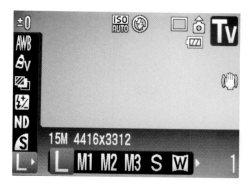 **Medium 1:** 3456 x 2592 pixels (approx. 9MP).
 This will use less memory than Large but is still a high enough resolution to allow significant cropping and produce good-quality prints of 11 x 17 inches (295 x 425 mm).
- **Medium 2:** 2592 x 1944 pixels (approx. 5MP).
- **Medium 3:** 1600 x 1200 pixels (approx. 2MP).
- **Small:** 640 x 480 pixels (approx. 0.3MP).
 This is a good resolution to use if you want to email images or upload them as illustrations on a website.
- **Widescreen:** 4416 x 2480 pixels (approx. 11MP).
 This alters the aspect ratio from 3:2 to 16:9, cropping a portion of the image from the longer sides of the full-dimensioned file.
- **RAW:** 4416 x 3312 (approx. 14.7MP).
 RAW files are always full resolution without compression. They have very little, if any, processing applied by the camera, and usually offer the highest quality images with a great amount of latitude for processing image attributes in the computer. However, special software is required to read and enhance them. One such program is Digital Photo Professional, supplied with your PowerShot G10 on the Canon Digital Camera Solution CD.

Note: You can record movies at two resolution settings: 640 x 480 pixels ▩ ; or 320 x 240 pixels ▩ . Set the Mode Dial to Movie mode ▣ and scroll to highlight the bottom icon in the FUNC. Menu. Then scroll right or left to select the desired resolution.

Shooting Mode Menus

When the camera is in the Shooting mode, you gain access to additional functions and features by pressing the MENU button, located on back of the camera in the lower right corner. A display showing four colored tabs (for four different menus) at the top will immediately fill the LCD screen. To switch between menu tabs, scroll with the right/left controller keys or pull/push the Zoom lever situated underneath the shutter button on top of the camera. Once you have selected the desired menu, scroll with the up/down controller keys (or rotate the Control dial) to highlight the item you want to activate. Some items will not be available in certain Shooting modes, especially in **AUTO** mode. If you don't see some of the menu items that are covered in this chapter while scrolling through the menus in your camera, try switching shooting modes.

Note: When you scroll down from a menu tab, that tab's color will remain as you move to highlight an item, and the other menu tabs will become grayed-out. Also note a scroll bar to the right of the menu items on the LCD. Since there is only enough room on the monitor to display six items, this bar tells if there are additional selections below or above the visible display.

To further choose options within a highlighted item, scroll using the left/right controller keys to make your selection. Note items under a menu tab that are followed by an ellipsis (. . .). This signifies that you must press ⊙ to reveal additional options for that item. Again, use the four-way controller keys to make your selections. Press the MENU button to confirm your settings and exit to the menu screen. Press MENU again or press the shutter button half way to exit the menu and to shoot a photo.

↺ *The G10 offers you a tremendous amount of versatility in terms of shooting with such menu options as AF Mode, Flash Control, and Spot AE Point, all of which give you the opportunity to optimize your photography. Photo © Matt Paden.*

The ☉ Menu consists of numerous items and options that let you control a variety of shooting operations.

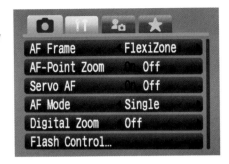

AF Frame	FlexiZone
AF-Point Zoom	Off
Servo AF	Off
AF Mode	Single
Digital Zoom	Off
Flash Control...	

☉ Rec. Menu

The Rec. Menu has a red tab with dozens of options with which you can make adjustments to the way you record images. The items and their options are:

AF Frame
The AF Frame controls the area within the frame where the camera focuses. See pages 123 – 124. Scroll with the left/right controller keys to select from several different options:
- **Face Detect:** The camera automatically focuses on a face that it detects within the scene. This is the default for the **AUTO** and **SCN** Shooting modes.
- **AiAF:** The camera automatically selects the AF area from among nine possible zones.

Note: You can also press the AF button ⊞ (on the back of the camera above and to the right of the Control dial) to select the different AF frames.

- **Center:** The AF frame is centered. This can be set only when the **AUTO** and **SCN** Shooting modes are active.
- **FlexiZone:** This allows you to move the AF frame.

AF-Point Zoom
This option is either [On] or [Off] (default). When [On], it allows you to magnify the AF frame so that you can more easily analyze focus in the LCD as you compose and preview a photograph (see page 130).

Servo AF is extremely useful when taking pictures of moving objects. Keep the shutter button depressed half way and the camera will track focus on the subject in motion. Photo © Kevin Kopp.

Note: You cannot activate AF-Point Zoom when the AF frame is set to [AiAF].

Servo AF
Again, this is either [On] or [Off](default). See page 126 for details on its use.

AF Mode

This allows you to set the way the camera will focus. This item has two options:

- **Continuous:** (Default) The camera will continue to focus on whatever you aim it at, even if the subject moves, and even without pressing the shutter button half way. This option is not available when the AF frame is set to [AiAF].
- **Single:** The camera will focus only when you aim and hold the shutter button halfway, and will lock focus at that point.

Digital Zoom

This item crops a portion of the entire scene on the sensor to narrow the field of view, so the center part of a full frame is actually recorded. That portion is then digitally sampled back up to full size, producing a telephoto effect.

- **Off:** Digital zoom is not active. The only zoom comes from moving the lens (optical zoom) with the zoom lever on top of the camera, in which case the range on the G10 is from a 35mm focal length equivalent of 28mm to 140mm.
- **1.7x:** The zoom will crop the image so that it appears as though the focal length has been increased by a factor of 1.7. In other words, multiply the optical zoom focal length range by 1.7. The focal length zoom range is now 47.6mm to 238mm (35mm focal length equivalent).
- **2.2x:** The same idea as 1.7x, but the multiplier factor is now 2.2, so the focal length zoom range on the G10 is equivalent to 61.6mm – 308mm.
- **Standard:** (Default) This combines digital with optical zoom to increase the focal length range so it extends from 28mm to 560mm.

Flash Control . . .

This offers you the ability to set a number of flash options to control the built-in and external flash lighting. After highlighting [Flash Control . . .], press ⬢ to reveal additional options with sub options.

Examine the results of flash pictures in Playback mode to determine if you need to alter the intensity of the flash. Make adjustments as required and reshoot.

Note: It is important to realize that not all Flash Control options are available in all Shooting modes. See pages 177 – 179 for more detailed information about how these flash control options function.

- **Flash Mode:** This controls the amount of flash illumination. Scroll left/right to toggle between [Auto] (default) and [Manual].
- **Flash Exp. Com:** Sets the intensity of the flash. Use the left/right controller keys to display settings in a range from –2 to +2 in increments of 1/3 stops. This can also be set in the FUNC. Menu (see page 68).
- **Flash Output:** Another function to control the light from the flash. When highlighted, use the left/right controller keys to toggle between [Minimum], [Medium], and [Maximum]. This can also be set in the FUNC. Menu.

- **Shutter Sync:** This determines the timing of the flash, whether it fires after the first shutter curtain opens or before the second curtain closes. Use the left/right controller keys to select either [1st-curtain] (default) or [2nd-curtain].
- **Slow Synchro:** The shutter can be set to speeds long enough to record ambient light. Scroll left/right to set this [On] or [Off] (default).
- **Red-Eye Corr.:** Use this function to reduce red-eye in people and animal photos. Select either [On] or [Off] (default).
- **Red-Eye Lamp:** This control will turn a light [On] (default) or [Off] that is used to reduce red-eye.
- **Safety FE:** This setting can automatically alter the shutter speed or f/stop when flash is active. The selections are [On] (default) or [Off].

i-Contrast

Select this item to automatically deal with high contrast situations (see pages 108 and 152). After scrolling down to highlight, use left/right controller keys to select [Auto] or [Off] (default).

Drive Settings . . .

Not to be confused with Drive modes, this menu item controls the length of delay and the number of shots taken when the timer is activated. The quickest way to use this setting is not to scroll down to this item from the ☐ . Instead, with the LCD on, first press the ⊑ ⊙ button (same as the down controller key) and scroll up/down to highlight 🔳 (Face Self-Timer) or ⊙ (Self-Timer). With that icon still highlighted, press MENU. The LCD will immediately display the corresponding option in the [Drive Settings . . .] item. Make your selection from the settings below and press MENU to confirm and exit:

- **Face Self-Timer:** This identifies and focuses on new face(s) that enter the frame, then records after a two-second delay. After highlighting, scroll with the right/left controller keys to choose a quantity of shots from 1 – 10.

- **Self-Timer:** Scroll with right/left controller keys to select a delay of ten seconds 🔟 , two seconds 💭 , or a custom delay 🔳 that you can determine.

Spot AE Point

This allows you to position the Spot metering point within the frame. (See pages 139 – 140 for more information on using Spot metering.) First press the 🔘 button (located on the back of the camera above and to the right of the Control dial) to display the metering screen on the LCD. Use the Control dial to select Spot metering 🔳 . Next, press MENU and scroll down from 🔳 to [AF Frame]. Select the option for [FlexiZone]. Then, continue to scroll down to [Spot AE Point]. Select from two options:

- **Center:** This positions the Spot AE point for metering in the center of the frame.
- **AF Point:** The Spot AE point will be positioned within the AF frame and can be moved within the scene on the LCD screen (see page 125).

Safety Shift

The shutter speed or aperture will automatically shift in **Tv** or **Av** Shooting modes to record a correct exposure when the original settings cannot produce a properly exposed photo. (see page 144 for further information).

- **On:** The adjustment will occur automatically.
- **Off:** No adjustment will occur.

Auto ISO Shift

This permits you to increase ISO automatically when the camera shake warning 🔳 flashes by pressing the Short-cut button 🔳 (located on the back of the camera in the upper right corner) while holding down the shutter button halfway. See page 47 for additional information.

- **On:** Allows 🔳 to increase ISO speed.
- **Off:** 🔳 will not automatically increase ISO speed.

MF-Point Zoom

In manual focus, this setting magnifies a portion of the LCD screen to make it easier to judge focus. See page 133 for more details.

- **On:** When the Focus mode must be set to manual, the center of the LCD screen will enlarge when you rotate the Control dial, allowing you to see details much more readily. Adjust focus with the Control dial.
- **Off:** A portion of the LCD screen will not become magnified.

AF-Assist Beam

When activated, a light will emit from the camera when ambient light is low in order to assist the AF system in finding focus.

- **On:** The green beam will shine when the shutter button is pressed half way in low lighting situations.
- **Off:** The beam will not turn on.

Review

Review allows you to determine the length of time a photo will be available for review in the LCD screen immediately after being recorded (Rec. Review). You are able to set the time period from 2 – 10 seconds in increments of one second. The following options are also available:

- **Hold:** The photo will display in the LCD indefinitely.
- **Off:** The Rec. Review image will not display in the LCD.

Review Info

This item produces optional ways to display in Rec. Review.

- **Off (default):** The standard image will display in the LCD for review as set in the [Review] item (see above).
- **Detailed:** The image for Rec. Review will appear smaller than normal, but will include shooting data about the image, including a histogram, Shooting mode, ISO setting, metering mode, shutter speed, aperture, file size, date, time, file name, exposure compensation, and white balance.

- **Focus Check:** The Rec. Review image will display along with a second image that is an enlarged portion from the focus area of the Rec. Review image. Check focus using the enlarged portion, and magnify even further using the Zoom lever.

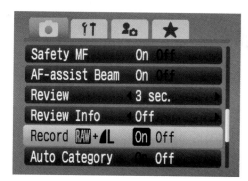

The G10 allows you to record both RAW and JPEG files at the same time.

[RAW] + ◢L Record

The camera simultaneously records a RAW file and a large-resolution, fine-compressed JPEG file of the same image. See page 58 for additional information.

- **On:** Both a RAW file and a JPEG file are recorded as described above.
- **Off:** Only a RAW file or a JPEG file will be recorded, depending on the setting for Recording Pixels in the FUNC. Menu.

Note: To record both a RAW file and a JPEG file simultaneously, this option must be set to [On] and [RAW] must be selected in the FUNC. Menu (Recording Pixels). Both images will be saved with the same file name to the same folder, but the [RAW] images will have a .CR2 suffix and the ◢L images will end with .JPG.

When Auto Category is On and the AF Frame is set to FaceDetect, the G10 will automatically categorize the photo as a "people" picture.

Auto Category

Images recorded in the **SCN** mode will be organized into three predetermined categories. See page 116 for additional information.

- **On:** Images will be sorted according to the following categories:

 🐾 **People:** For images recorded in [Face Detect] mode and in 🔆 , 📷 , and 🎇 Shooting modes.

 🏔 **Scenery:** For pictures recorded in 🏔 , 📷 , 🌄 , and 🎿 Shooting modes.

 🎾 **Events:** For images recorded in 🎿 , 🎆 , ⛄ , 🏂 , 🎆 , 🎇 , and 🎐 Shooting modes.

- **Off:** Photos are not categorized.

Note: Movies are not sorted under this setting, but may be categorized using My Category (see pages 103 – 104).

IS Mode

This sets the Image Stabilization (IS) function (see page 47 for additional information).

- ▦ **Off:** Image Stabilization is not active.
- ▦ **Continuous:** IS is on all the time, even when previewing the scene on the LCD screen.
- ◉ **Shoot Only:** IS is in effect when the shutter button is pressed. This can be set for still photos only.
- ⇥ **Panning:** Only the up/down motion of the camera is stabilized, so you can move the camera horizontally to follow a moving subject.

Note: These icons will appear slightly differently if using a converter lens with the [Converter] option selected in the ◉ Menu (see below), though their functions remain the same.

Converter

If using Canon's compatible TC-DC58D teleconverter (sold separately), set this item to [TC-DC58D] in order to use the IS functions described above. See page 188 for more information.

Custom Display . . .

This item offers choices for what data you want to display on the LCD screen each time ⊚ is pressed as you preview a scene. Scroll within the options below and press

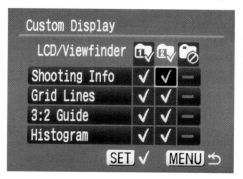

You can choose a couple of different sets of data to display in the LCD or Viewfinder. Switch between them by pressing the DISP. button.

83

to place a check mark in the box you want to activate for display for each view.

- **▣/▣/▣ LCD/Viewfinder:** When all three icons appear with a checkmark, you can call up three different LCD displays while in Shooting mode by successively pressing (DISP) (Info View 1, Info View 2, No Display, respectively). Highlight a display icon and press (FUNC/SET) to disable that view from displaying (designated by a circle with a line through it). To add options to Info Views 1 and 2, use the up/down keys to scroll and (FUNC/SET) to select. Choose from these options:

- **Shooting Info:** Depending on the Shooting mode, this shows such current settings as Recording Pixels, compression, Shooting mode, shutter speed, aperture, white balance, ISO, metering mode, exposure compensation, battery level, etc.

- **Grid Lines:** Displays vertical and horizontal grid lines that trisect the screen to facilitate composition.

- **3:2 Guide:** Displays a portion of the standard 4:3 aspect ratio as gray to indicate where the image would be cropped to make a print in 3:2 aspect ratio.

- **Histogram:** Displays a histogram in Shooting modes **P** , **Tv** , **Av** , and **M** .

Set Shortcut button . . .

This allows you to assign a predetermined function to the ⟁ button (located on the back of the camera in the top left corner), so you can set that function without scrolling through numerous menu options. Highlight the option and press (FUNC/SET) to set.

- ⟁ No assignment
- ND Select ND Filter
- WB Select White Balance
- ▣ Record Custom WB1 (use white target)
- ▣ Record Custom WB2 (use white target)
- ◎ Toggle to alternate between active and not active red-eye correction

If you come back to shoot certain types of scenes time and again, like sunrises for example, you can set the camera to its optimal settings and save them for the next time you are in the mountains at dawn. Photo © Kevin Kopp.

- **T** Activate the digital teleconverter, and increase focal length multiplier by pressing Shortcut button successively.
- **Qi** Alternate between active and not active i-Contrast
- **AFL** Activate AF lock
- **zz** Alternate between turning LCD off and on.

Save Settings . . .

This item saves a number of camera settings in the Creative Zone Shooting modes, including Recording Pixels, shutter speed and/or aperture, white balance, My Colors, metering mode, flash mode, and others. You can then recall these settings at a later time via the C1 and/or C2 modes on the Mode dial (see page 84 for more information).

- **Destination:** Set the camera as you want it in the Creative Zone modes, and then select either [C1] or [C2] in this menu. Press ⓕ to save that collection of shooting settings. Move the Mode dial to point at C1 or C2— whichever destination you selected— any time later to recall the saved settings and take the picture. Repeat the process to change the C1 or C2 settings.

🔧 Set Up Menu

The Set up Menu controls the basic organization of the camera, like a type of administrator. These are settings you usually will not change frequently because they represent an infrastructure of the shooting, playback, and printing functions. Identical Set up Menus exist in both the Shooting Mode Menu and the Playback Mode Menu.

The Set up Menu controls a number of important features, like the volume of camera sounds and which language to use in the menus display.

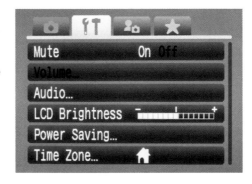

Again, the basic navigation for menus applies. Press MENU and scroll with the right controller key to 🔧 . Scroll with the up/down controller keys or the Control dial to select the desired item. If the item has an ellipsis (. . .), press ⓕ to display further options; if not, scroll with the left/right controller keys to select the appropriate option. Press MENU to set and exit.

Mute

This setting controls the camera's operational sounds.

- **On:** The camera will be silent except for an audible warning when the memory card/battery door is opened during shooting.
- **Off (default):** Sound effects will be audible for a series of camera operations (see the listing in Volume below).

Volume . . .

Use the left/right controller keys to set the volume level in five increments for several camera operations. Press the left/right controller keys to increase or decrease.

- **Start-up Vol.:** Sound when turning the camera on.
- **Operation Vol.:** Sound when a button on the camera is pushed.
- **Selftimer Vol.:** Sound made by camera before shutter is released when timer is active.
- **Shutter Volume:** Sound when shutter releases.
- **Playback Vol.:** Audio during playback of movies, voice memos, and sound recording.

Audio . . .

The Audio item offers the ability to change the microphone level—e.g. recording level— of movies, sound memos, and the sound recorder, as well as wind filter settings. See page 111 for additional information.

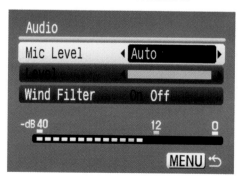

Switch the Mic Level from Auto to Manual in order to increase or decrease the Level slider and gain additional control over the recording level.

87

It might be difficult to view scenes or playback images in the LCD on bright days. In that case, adjust the LCD brightness in the Set up Menu.

- **Mic Level:** Toggle between [Auto] (default) and [Manual]. If [Manual] is selected, use the down controller key to highlight the recording level (volume) bar, which can be adjusted from −40 to 0 dB using the left/right controller keys. Selecting [Auto] makes the recording volume adjust automatically to prevent distortion of the sound.
- **Wind Filter:** Set to [On] whenever there is a strong wind, or to [Off] (default) using the left/right controller keys. The icon appears when this function is set to [On]. Press the MENU button twice to exit.

Note: The recording will have an unnatural sound if the filter is set to [On] and there is no wind.

LCD Brightness

Increase the brightness of the LCD so it is easier to see in different types of ambient lighting. Scroll with the left/right controller key to increase and decrease the brightness on a horizontal scale between increments from −7 through +7 (0 is the default).

Power Saving . . .

The camera is equipped with a power-saving function that can be set to automatically turn off the camera or the LCD screen after a given time frame to conserve battery power.

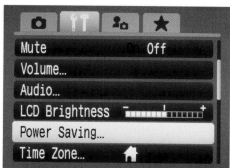

Conserve battery power by setting the camera and the LCD display to turn off automatically if not used within a certain time frame.

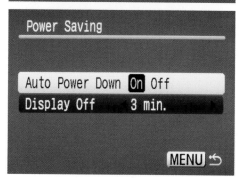

- **Auto Power Down:** Select [On] (default) or [Off]. When set to [On], the camera will power down within about three minutes if no additional operations are started in Shooting mode, or about five minutes after the last control is accessed in Playback or Printing mode.

- **Display Off:** Set the duration, at predetermined intervals between ten seconds and three minutes, that the LCD will stay on before automatically powering down by scrolling with the left/right controller keys.

Note: The power-saving function will not activate during a slide show or when the camera is connected to a computer.

Time Zone

When traveling to other time zones or different countries you can record images with local dates and times simply by switching the time zone setting if you pre-set the destination time zones. This is more convenient than having to switch them manually each time they change. After selecting [Time Zone], press ⟨⟩ to see:

When traveling, you can preset the G10 to document the local time where your photos will be recorded.

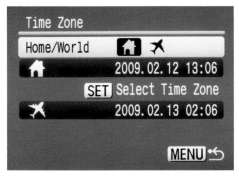

- **Home/World:** Use the left/right keys to toggle between ⌂ (Home time zone—default) and ✈ (World time zone). Select ⌂ and press ⟨⟩ . A map will display. Select your Home time zone using the left/right controller keys; the down key allows you to select Daylight Savings Time or not (☀). Press ⟨⟩ again to input your setting and return to [Home/World].

With the Home time zone set, you can now select the World time zone ✈ using the right controller key and scrolling left/right to choose a destination area on the map display. Set the time zone by pressing ⟨⟩ , and

exit by pressing MENU . But before exiting, make sure the 🏠 icon is highlighted (if you are still in your home time zone). The ✈ time zone will be ready for future use; simply gain access to Home/World again and select ✈ , then exit the menu.

Date/Time

The menu to set the date and time in your camera will automatically display when you turn the camera on for the first time. To make changes at a later time, select [Date/Time] and press either 🔘 or the right controller key. A yellow bar will appear that allows you to use the controller keys to set the month, day, year, hour, and minute, as well as the format for this information. Again, highlight ☀ if you want to select Daylight Savings Time.

Clock Display

The current hour, minute, and second can be displayed in the LCD by pressing and holding 🔘 . This item allows you to set the duration of this display by using the left/right controller keys, for predetermined lengths from 0 seconds to three minutes.

Format . . .

Formatting the memory card erases all existing images and data, including those that have been protected. However, it is a good idea to do on occasion, since the procedure helps safeguard against data corruption.

After highlighting [Format . . .] and pressing 🔘 , a screen displays showing how much of the current card's total memory has been recorded, with choices to highlight [Cancel] to return to the menu or [OK] to format (initialize) the card. Scroll to make your selection and press 🔘 to enact your choice.

- **Low level Format:** This setting is recommended when you believe that the recording/reading speed of the card has decreased. Use the left/right controller keys to add a check mark in the displayed box, use the four-way controller to select [OK] and press 🔘 to format the card.

Note: You can stop formatting by pressing ⊛ . A low level format may take 2-3 minutes with some memory cards.

File Numbering

All images shot with the camera are automatically assigned file numbers, but you can select how the file number is assigned.

- **Continuous (default):** Each sequential image is one number higher than the image that came before it. This includes any previously recorded images that remain on a card, or when starting a new blank card.
- **Auto Reset:** The image file and folder are automatically set to start at 100 (folder number)-0001 (file number) when a blank memory card is used.

Create Folder . . .

New folders can be created at any time, and the recorded images will automatically be saved to that folder.

- **Create New Folder:** A new folder will be created the next time you record images. Use the left/right controller keys to put a check mark next to [Create New Folder], and press MENU .
- **Auto Create:** Specify a date in this field, from [Off] (default) to [Daily], [Monthly], or to any specific day of the week. Then scroll down to set the start time. As an example, if you choose [Tuesday], a new folder will be created every Tuesday at the specified time. Press MENU to set and exit.

Note: Up to 2000 images can be saved into one folder.

You might want to create a new folder on your memory card when ⇨
you go on a specific photo shoot so that all the pictures taken at that time are grouped together.

Auto Rotate

The G10 has a sensor that detects the orientation of an image shot when the camera is held in the vertical position. It automatically rotates the image to the correct orientation when you view it on the LCD screen.

- **On (default):** Vertical images display vertically (therefore not filling the full screen) when viewed on the LCD.
- **Off:** Rotate does not operate, so the image will be displayed on the full screen.

Note: The icons 🔒 will appear in the LCD when it is set to display details, signifying that this feature is activated. The Auto Rotate function may not operate properly when the camera is pointed straight up or down.

Distance Units

Set the Zoom bar and the MF indicator to display in measurements of either [m/cm] (default) or [ft/in].

Lens Retract

Set the duration at which the lens will retract after switching from Shooting to Playback mode, either [1 min.] (default) or [0 sec.].

Language . . .

Press 🔘 to select from over 25 language choices to use for all menu displays. Press 🔘 again to set.

Video System

Select [NTSC] or [PAL]. See page 173 for additional information.

Print Method

Select the way the camera interacts with certain Canon compact photo printers.

- **Auto (default):** The normal setting for images printed at all Recording Pixel sizes other than W (Widescreen).
- W **(Widescreen) mode:** For making borderless prints of images shot in W on wide paper using selected Canon compact photo printers.

You can set the camera so that wide aspect (16:9) photos will print directly on compatible Canon printers. Photo © Jeff Wignall.

Reset All . . .

This allows you to return all camera settings to their defaults in one quick operation.

- **OK:** Will reset the camera. Select and Press ⬚ to complete.
- **Cancel:** Will not carry out the reset. Highlight [Cancel] and press ⬚ or MENU to leave the camera's settings as is and return to ⬚ .

Note: When returning the C1 and C2 contents to the default setting, turn the Mode dial to C1 or C2 to perform the operation. Settings cannot be reset when the camera is connected to a computer or a printer. Also, the following cannot be reset using this feature: Shooting mode, Time Zone, Date/Time, Language, Video System, ISO speed, exposure compensation, Custom white balance data, colors specified in [Color Accent] or [Color Swap] modes, and newly-added My Camera settings.

Make your G10 reflect a bit of your personal style by customizing features in the My Camera Menu.

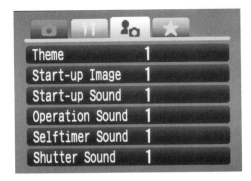

🖪 My Camera Menu

This menu item has options to customize the way the LCD appears when the camera starts up, as well as the types of sounds the camera makes. This is less about shooting and playback, and more about having fun while making the camera reflect your tastes and personality. You can choose from preset images and audio clips. You can also select images on your memory card or computer to register as start-up visuals, as well as register sound recordings you have made with the camera for the audio clips.

Scroll down and/or up using the controller keys or the Control dial to select any of the items you wish to set.

Theme number 3 shows a greenish background with a floral pattern for the camera's start-up image.

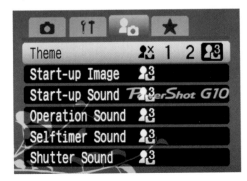

Then, for each item, scroll using the left/right controller keys to highlight one of four options. The first option for each item, 🔊 with an X, makes that item non-operational. The next selections appear as 1, 2, and 📳 , each with their own content. As you highlight an icon, it will visually or audibly indicate what you are setting. The My Camera items are:

- **Theme:** Selecting any of the four options will apply its settings to all subsequent items in this menu. For instance, if you choose Theme number 2, then all of the following items [Start-up Image], [Start-up Sound], etc.) will automatically have option 2 selected: You will not need to scroll down to set any of the other items. However, the Theme's automatic settings can be overridden by individually setting any or all of the individual items below.

- **Start-up Image:** An image that briefly displays when the camera is turned on.

- **Start-up Sound:** The sound that is heard when the camera is turned on.

- **Operation Sound:** Sound made when pressing any of the camera's buttons.

- **Selftimer Sound:** The sound made as the self-timer counts down before firing.

- **Shutter Sound:** The sound made when the shutter button is pressed.

Registering My Camera Settings: This is a function of the ▶ Menu. See page 118.

⭐ My Menu

In My Menu, you can register up to five items of your choice from the 🔘 Menu to appear in a single display. This is convenient because it allows you to gain quick access to them without scrolling through a number of different screens. In fact, your registered My Menu items can be set to display immediately after pressing MENU in the Shooting mode.

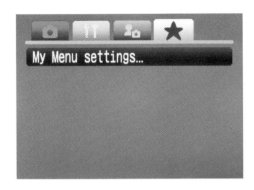

My Menu settings...

My Menu settings . . .

- **Select items . . . :** A list of all the 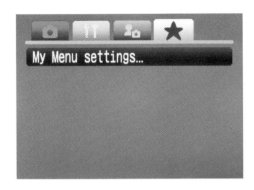 Menu items displays. Highlight an item by using the up/down controller keys and press ⌾ to select, placing a check mark in a box to the right of the item. You can register items even if they appear gray, though applying those items will depend on the Shooting mode. Repeat up to five times and press ⌾ to set your selections.
- **Sort . . . :** Once your items are selected, use this option to arrange them in a sorted order that you want. Highlight the My Menu item that you want moved, press ⌾ to display up/down arrow buttons, and use the up/down controller keys to reposition the item. Scroll to other items to move them as well. Press MENU to set the new order.
- **Set default view:** Select [Yes] or [No]. [Yes] displays the registered My Menu items immediately after pressing MENU in the Shooting mode; [No] displays the normal ▣ Menu.

Playback Mode Menus

The Playback mode is one of the greatest features of digital photography. Use the LCD to review the photos and movies you record. You can analyze your photography, noticing what effect different settings have on the pictures. Experimentation is inexpensive and the results are immediate. Using the playback features found in the G10 allow you to learn more about how to take better pictures, and also eliminate poor photos to lessen clutter on the memory card.

▶ The Play Menu

The Play Menu ▶ controls the features when the camera is set to Playback mode. Press the ▶ button (on back of the camera above the top right corner of the LCD screen) to enter Playback. If the camera is off, pressing the ▶ button will turn the camera on, giving immediate access to this mode. Press MENU and scroll with the right controller key to

the ▶ tab. Navigate to the items, options, and sub-options as with the other menus, scrolling with the up/down controller keys or the Control dial to select the desired item. If the item has an ellipsis (. . .), press ⓕ to display further options; if not, scroll with the left/right controller keys to select the appropriate option. Press MENU to set and exit.

Slide Show . . .

Instead of reviewing images one at a time by pressing a controller key or using the Control dial, you can make the images play back automatically. After pressing ⓕ to display the control screen to set up the slide show, scroll down to highlight a blue bar with several slide show icons, then use the left/right controller keys to select a slide show style from the icons:

- ▣ : All images on the memory card.
- ▦ : Images recorded on a selected date.
- ▩ : Images recorded in a selected **SCN** Shooting mode.
- ▇ : All the images from a specific folder.
- ▨ : Movie files only.
- ▣ : All the still photos only.
- **1** - **3** Custom 1–3: Selected still images.

In the blue icon bar, scroll to **1** (Custom 1) and press ⓕ . The last playback image will display; you can use the Zoom lever to produce an index display or single image display. Scroll from image to image and press ⓕ for each one you want to include in the Custom slide show—a check will mark each selected image (the number to the left of the check mark indicates the selection order in which the images will display). Repeat until all desired images are selected. If you want to cancel an image from the slide show, select it and press ⓕ again. Press MENU to return to the slide show screen.

Before you begin your slideshow, select from three different transition effects as the slide show changes from one image to the next. From the blue icon bar, scroll up with the controller key to highlight the Effect box, then scroll with

the left/right controller keys to choose the type of effect you want, as illustrated in the Effect box.

Note: When **+1** is set, a check mark will appear with the icon. **+2** will now be apparent in the blue icon bar. **+2** and **+3** will likewise change as they are also set.

You can create a slide show of all photos on your memory card or of selected images, complete with transition effects.

Now scroll to the bottom of the LCD screen and highlight [Set up], then press 🔘 . A screen will appear that allows you to set the duration that each image will display in the slide show (up to 30 seconds) and whether the slides will repeat until the show is cancelled. Press MENU to confirm these settings.

To start the slide show, scroll to the bottom of the LCD screen and highlight [Start], then press 🔘 . To pause or resume the slide show, press 🔘 again. To fast forward or rewind, press the left/right controller keys, respectively, holding them down to switch between images more rapidly.

My Category . . .
In addition to setting up criteria to sort photos in ◉ (see pages 97 – 98), you can categorize recorded images in ▶ .
• **Select:** Use to view and categorize one image at a time. Highlight [Select] and press 🔘 . A playback image will appear with a column of category icons on the left side of the LCD. Use the up/down controller keys to highlight a category for the image on display and select

103

It is sometimes convenient to playback only selected categories of recorded images; you may want to review only the landscape shots that are on your memory card. Photo © Kevin Kopp.

by pressing ⊛ . You can place the same image into more than one category in this manner. Press the ⊛ button a second time to cancel the category selection. Press MENU to exit.

- **Select Range:** Use to select a range of photos to apply to a category. After highlighting [Select Range], press ⊛ and a photo outlined in a blue frame will display. Press ⊛ , then scroll among the recorded images, either in the single image or index playback formats, and highlight the one you want to be the first in the range. Press ⊛ to select. Then use the right controller key to highlight the next square and again press ⊛ and scroll to select a photo that will be the last photo in the range; press ⊛ to confirm. Then press the down controller key to highlight the category bar and select a category using the left/right controller keys. When finished choos-

ing a category, scroll down to choose [Select] (or [Dese-lect]), and then press (FUNC SET).

> **Note:** The image you select as the last image in the range must have a higher file number than the one selected as first in the range.

Erase . . .

Erasing deletes unprotected images from the memory card (see page 166 for additional information). You can erase images as you view them in playback by pressing the 🗑 button on the back of the camera. Or you can also use this menu item to select images to erase.

- **Select:** Press this item and individual images display on the LCD. Press (FUNC SET) to erase these playback images, or MENU to return to the menu without erasing.

- **Select Range:** Select a first and last image from those recorded and erase them as well as all images in between (see [Select Range] previous page for selection informa-tion). Scroll down to highlight [Erase] and press (FUNC SET) to execute or MENU to cancel.

- **Select by Date:** All images will display categorized by date or recording. Scroll to highlight a date and select by pressing (FUNC SET). A check mark will appear on the selected date. (Press (FUNC SET) again to cancel the check mark). Press MENU to erase images recorded on the selected date(s).

- **Select by Category:** All images will display sorted by categories as produced by Auto Category or My Cate-gory. Scroll to highlight a category and select by press-ing (FUNC SET). A check mark will appear on the selected categories. (Press (FUNC SET) again to cancel the check mark). Press MENU to erase the selected files.

- **Select by Folder:** All images will display sorted by folder number. Scroll to highlight a folder(s) and select by press-ing (FUNC SET). A check mark will appear on the selected folders. (Press (FUNC SET) again to cancel the check mark). Press MENU to erase the selected folders.

- **All Images:** Highlight [OK] and press (FUNC SET) to erase all images recorded on the memory card. Press [Cancel] to return to the Erase menu without erasing the images.

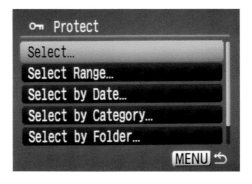

Free up space on your memory card by selecting to protect the best photos and erasing all the rest.

Protect . . .

Protecting images (locking) prevents them from being erased. It helps prevent accidental deletion of photos that you want to keep.

- **Select:** Press this item and individual images display on the LCD. Press ⓢ to protect these playback images, or MENU to return to the menu without applying protection. Protection is signified by a key icon ⚷ appearing on the image.

- **Select Range:** Select a first and last image from those recorded and protect them as well as all images in between them (see [Select Range] page 104 for selection information). Scroll down to highlight [Protect] and press ⓢ to execute or MENU to cancel. Use this option and highlight [Unlock] to remove protection from a range of image files.

- **Select by Date:** All images will display categorized by date of recording. Scroll to highlight a date and select by pressing ⓢ . A check mark will appear on the selected date. (Press ⓢ again to cancel the check mark). Press MENU to protect images recorded on the selected date(s).

- **Select by Category:** All images will display sorted by categories as produced by My Category or Auto Category. Scroll to highlight a category and select by pressing ⓢ . A check mark will appear on the selected categories. (Press ⓢ again to cancel the check mark). Press MENU to lock the selected files.

*The **G10** offers several different ways to choose which of your favorite photos to protect from erasure. Among the various choices, you can select the pictures one-by-one, all photos recorded on a particular date, or safeguard all images on the card. Photo © Jeff Wignall.*

- **Select by Folder:** All images will display sorted by folder number. Scroll to highlight a folder(s) and select by pressing ⬤ . A check mark will appear on the selected categories. (Press ⬤ again to cancel the check mark). Press MENU to protect the selected folders.
- **All Images:** Highlight [Protect] and press ⬤ to protect all images recorded on the memory card. To remove protection from all images on the card, press [Unlock]. Select [Stop] to quit the process once initiated. Press MENU to return to the Protect menu without locking the images.

i-Contrast . . .

This brightness control can be set to compensate for overly light or dark areas before recording (see page 78), or can be used in ▶ to apply similar processing to images stored to the memory card. After pressing (FUNC/SET), an image for play-back review will display. Use the left/right controller keys or the Control dial to choose an image for i-Contrast processing and press (FUNC/SET). Scroll with the left/right controller key to apply various levels of processing: [Auto], [Low], [Medium], or [High]. Watch the LCD to see the affect of each selection as you scroll through the choices. Press (FUNC/SET) to apply i-Contrast, or press MENU to exit without applying. Your corrections will be saved as a new image.

Red-Eye Correction . . .

You can correct people pictures that exhibit red-eye (see page 78). In the Playback menu, highlight [Red-Eye Correc-tion] and press (FUNC/SET) to gain access to Playback mode; then use the left/right controller keys or the Control dial to select the image from which you want to remove red-eye, and press (FUNC/SET) again to select it. This will display a screen with several options plus a frame in the picture around eyes where red-eye is detected. If red-eye is not automatically detected, use the four-way controller to select [Add Frame] and press (FUNC/SET). To cancel the correction frame, select [Remove Frame] and press the (FUNC/SET) button.

To correct the selected image (when the frame automati-cally appears), select [Start] and press (FUNC/SET). Red-eye in the photo will now be reduced. Save the corrected image by highlighting either [New File] (which will save both original and the newly processed file) or [Overwrite] (which will replace the original with the corrected file), and then press (FUNC/SET). To display the saved image, press the ▶ button and select [Yes], then press (FUNC/SET).

To correct an image where the frame around the eyes does not automatically appear, select [Add Frame] and press (FUNC/SET); a green frame will display. Adjust the position of the frame with the four-way controller to go around the red-eyes

You can lighten dark areas in your photos, such as the cloth curtain hanging from the bell table, with the i-Contrast control. However, apply the minimum amount necessary, trying not to introduce noise or artifacts during the correction. Photo © Kevin Kopp.

in the photo, and adjust the size of the frame with the zoom lever. Press ⬛ to confirm; up to 35 frames can be added. When finished, apply the corrections by pressing ⬛ to return to the Red Eye menu, and select between [New File] and [Overwrite]. To remove frames, select [Remove Frame] and press ⬛ . Select the frame to be removed with the left/right controller key, and delete with ⬛ .

Trimming . . .

Eliminate unwanted portions of a picture by trimming (see page 168 for additional information). In the Playback menu, highlight [Trimming] and confirm the selection by pressing (FUNC SET) . A smaller version of the image will appear with a green crop frame. The area of the green frame can be adjusted using the zoom lever—however, this does affect the resolution of the saved image. The crop frame's position can also be moved using the four-way controller, and the orientation (horizontal/vertical) can be changed by pressing (DISP) .

To execute the crop when the green frame is positioned as desired, press (FUNC SET) and highlight [OK]. Confirm by pressing (FUNC SET) again. To display the saved image of the cropped area, press (FUNC SET) , select [Yes], and press (FUNC SET) . The aspect ratio will be fixed at 4:3, and the resolution will be reduced.

Resize . . .

Save copies of images at a lower Recorded Pixel setting (resolution) than originally recorded (see page 70 for additional information). Select the image by highlighting [Resize] in the Playback menu and pressing (FUNC SET) .

- **M3:** Save a copy of the original at 1600 x 1200 pixels (approximately 2MP).
- **S:** Save a copy of the original at 640 x 480 pixels (approximately 0.3MP)
- **XS:** Save a copy of the original at 320 x 240 pixels (approximately 0.7MP)

Highlight the desired image size and press (FUNC SET) to execute. To save the resized image, select [OK] and press (FUNC SET) . To display the newly saved image, press MENU and press [Yes].

My Colors . . .

Add color processing to recorded images (see page 65 for additional details). Select the playback image to adjust by highlighting [My Colors] in the Playback menu, pressing (FUNC SET) , and scrolling to select the desired image. Scroll to highlight one of the My Colors icons that appear at the bottom of the LCD (the displayed image will reflect the different effects of the My Colors

settings as you scroll through the icons). You can pull the Zoom lever clockwise to check the image at higher magnification, and press ⓢ repeatedly to switch between the transformed image and the unaltered original (before-and-after shots). Press ⓢ to confirm the My Colors effect, and save the processed image by selecting [OK] and pressing ⓢ again.

Sound Recorder . . .
You can record audio memos to go along with your images or movies by pressing the 🎤 button (see pages 87 – 88). With this menu item, however, you record only sound; it is not an attachment to an image.

Press ⓢ to display a screen with an audio panel along the bottom; a red circular icon (⬛) will be highlighted to signify the record mode. First use the up/down controller keys to determine the sampling rate (sound quality improving successively at settings of 11.025kHz, 22.050kHz, and 44.100kHz). Then press ⓢ to start the recording, and press again to pause or end the recording (repressing ⓢ after stopping will restart the recording process).

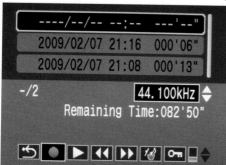

The G10 nearly offers a mini recording studio within its Playback mode.

When done recording, press ⓢ to end and scroll with the left/right controller keys to highlight another icon. Highlighting ▶ will give you the opportunity to scroll up/down in the top portion of the LCD display to select a specific recording (based on date and time) if you have recorded more than one. Activate any of the sound icons by pressing ⓢ .

- ⏏ : Exit sound recording.
- ⏺ : Record the sound.
- ▶ : Play the recording.
- ⏪ : Rewind the audio recording.
- ⏩ : Fast forward.
- 🗑 : Delete the sound recording.
- 🔒 : Protect the sound recording.

The far right icon lets you increase or decrease volume by using the up/down controller keys.

Rotate . . .

Rotate images as they appear in the LCD. Select the playback image you want to rotate and press 🔘 repeatedly to successively rotate the image at 90°, 270°, and back to the original orientation. Although the orientation is recorded in the image, results may vary depending on the software used when transferring the images to a computer. Press MENU to exit the Rotate item.

Transfer Order

This sets specifications for files to download and print directly from the camera on a compatible printer.
- **Order:** Highlight and press 🔘 to select playback images one at a time. Press 🔘 again to deselect.
- **Mark all:** Highlight and press 🔘 to select all images on memory card.
- **Reset:** Cancels all previous transfer order settings.

Resume

This item controls which image will appear in the LCD when the ▶ button is pressed, the image that was [Last seen] when reviewing pictures, or the image that was [Last shot].

Transition

You can control the appearance of the transition as playback switches from one picture to another.

- ▣ : No effect; one picture leaves and another appears.
- ▓ : The screen very briefly turns black between images.
- ▢ : The images are like a deck of cards with the top one sliding off to the side or coming in from the side, depending on the direction you are scrolling to view the images.

🖨 Print Menu

You can print directly from the PowerShot G10 to a compatible printer without downloading to a computer. This menu allows you to specify which images to print, the number of photos to a page, and the quantity of each image to print, complying with the Digital Print Order Format (DPOF) standards. Navigate, as always, with the four-way controller keys and the 🔘 button. If the item has an ellipsis (. . .), press 🔘 to display further options; if not, scroll with the left/right controller keys to select the appropriate option. Press MENU to set and exit.

Print . . .

This item is active when files have been specified for printing and the camera is connected to a compatible printer with the IFC-400PCU interface cable, included with the G10 camera kit. It lets you select from several image enhancements and formats for printing.

- **Image Optimization:** Scroll left/right to select from enhancement settings. [Vivid], [NR] (noise reduction), [Vivid + NR], [Face], [Default], [On], [Off].
- **Paper Settings:** select size and format.
 - **[4x6]:** Photo, Fast Photo, Default
 Borderless, Bordered, Default
 - **[5x7]:** Photo, Default
 Borderless, Bordered, Default
 - **[8.5x11]:** Photo, Fast Photo, Plain , Default
 Borderless, Bordered
 - **[N-up]:** Default

[CreditCard]: Photo, Default
Borderless, Bordered, Default
[Default]: Photo, Default
Borderless, Bordered, Default

• **Print**

First select the Print Settings item to determine the style of prints, or Print Type, then choose the image files you want to print.

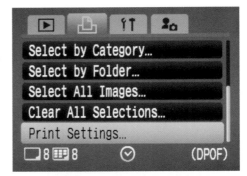

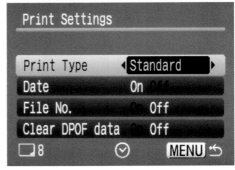

Select Images & Qty . . .

This defines the print quantity for images you select for printing as you view them during Single Image Playback. Highlight this item and press ⊛ to display a playback image. When [Standard] or [Both] has been previously selected in the [Print Type] option (see [Print Settings . . .] below), a playback image will display with a counter window in the upper left corner to input print quantities. Scroll with the left/right controller keys to select a specific image you want to print, then press ⊛ to activate the counter window, using the up/down controller keys to determine the

114

print quantity. Repeat the procedure to select and specify as many other images as you want to print, and press MENU to set the selections and exit to the ⬛ Menu.

When [Index] has been previously selected in the [Print Type] option, choose which of the images you want to appear as part of the index format print by pressing 🔘 as you scroll through Single Image Playback.

Select Range . . .
This selects several photos to print, in a similar way that a range of photos is selected to display in My Categories (see page 104).

After highlighting [Select Range], press 🔘 and a photo outlined in a blue frame will display to the left of the LCD. Press 🔘 , then scroll among the recorded images, either in the single image or index playback formats, and highlight the one you want to be the first in the range. Press 🔘 to select. Then use the right controller key to highlight the next square and again press 🔘 and scroll to select a photo that will be the last photo in the range; press 🔘 to confirm. Then press the down controller key to highlight [Order] and press 🔘 to set.

Note: The image you select as the last image in the range must have a higher file number than the one selected as first in the range. Up to 500 photos can be selected for printing.

Select by Date . . .
Windows will appear in the LCD screen after selecting this item that allows you to choose photos for printing based on the date they were recorded. Scroll up/down to highlight the date(s) you want (all the files recorded on that date will be included in your selection) and select by pressing 🔘 —a check mark will appear in a thumbnail image representing that date. (Deselect the date if needed by pressing 🔘 again).

Once you have checked all the dates you wish to print, press MENU and complete by scrolling and highlighting [OK]. Confirm by pressing MENU .

115

Select by Category . . .

The procedure for this is exactly like selecting photos by date, except the choices appear according to the photos organized by My Category and Auto Category. You determine whether you want to print photos classified by [People], [Scenery], or [Events].

Scroll up/down to highlight the category(s) you want and select by pressing ⓕ —a check mark will appear in a thumbnail image representing that category. (Deselect if needed by pressing ⓕ again). Once you have checked all the categories you wish to print, press MENU and complete by scrolling and highlighting [OK]. Confirm by pressing MENU .

Select by Folder . . .

This item is selected, as you might think, according to the file folder(s) on the memory card. The process is the same as for Date and Category.

Select All Images . . .

This gives you the opportunity to make one print of all the images on your memory card. Select [OK] and press ⓕ .

Clear All Selections . . .

Deselect all the files you may have chosen for printing with one selection of the [OK] button, pressing ⓕ to confirm.

Print Settings . . .

Set the style of print you want.

- **Print Type:** This tells the printer whether to produce photos as index prints, individually per page, or both.
- **Date:** Select [On] or [Off] (default) to determine whether or not to add the date to your print(s).
- **File No.:** Select [On] or [Off] (default) to determine whether or not to add the file number to your print(s).
- **Clear DPOF data:** Select [On] (default) or [Off] to clear all printing settings to give a "clean slate" after images print.

Scroll left/right to highlight selections, and press MENU to confirm.

Your G10 can print photos without a computer; simply attach it to a compatible printer with the supplied cable and you can print any of the photos stored on the memory card in the camera. Photo © Jeff Wignall.

🔝 Set Up Menu

This menu in the Playback mode is the same as in the Shooting Mode Menu system. See page 86.

You will find a Set up Menu in both the Shooting mode and Playback mode menu systems.

📷 My Camera Menu

This menu appears in both the Shooting Mode Menu and the Playback Mode Menu. Its application is explained on page 96. Once again, the items are:

* Theme
* Start-up Image
* Start-up Sound
* Operation Sound
* Selftimer Sound
* Shutter Sound

However, new images and sounds can be registered to My Camera settings exclusively in the Playback mode. To do so, press the ▶ button, then press the MENU button and scroll to highlight 📷 . Scroll down to highlight [Start-up Image], and use the left/right controller keys to select 🔋 . Next press 🔘 to display Single Image Playback, and scroll to choose an image. While viewing the chosen image, press 🔘 to select it to display at camera start up.

118

Theme	1		
Start-up Image	1		
Start-up Sound	1		
Operation Sound	1		
Selftimer Sound	1		
Shutter Sound	1		

Some of the My Camera settings, which determine features like the camera's operational sounds and start-up image in Shooting mode, can be set to different choices for Playback mode.

Scroll down to register for the other (audible) items. Use the left/right controller keys to select 🔳 and press the 🔘 to display a screen with a control panel at the bottom. Scroll to highlight the desired action:

- 🔙 : Exit the screen before registering.
- ⬜ : Highlight and press 🔘 to start recording a sound. Press ⬜ again to pause or stop recording.
- ▶ : Play the recorded sound
- 🔁 : Highlight after recording to register the sound. Press 🔘 and select [Cancel] or press [OK], again pressing 🔘 to apply your final selection.

Note: Sounds recorded with the Sound Memo or Sound Recorder functions cannot be registered as My Camera settings. The previous setting is erased when a new My Camera setting is added.

The supplied Canon software, ZoomBrowser EX/Image-Browser, must be downloaded to a computer and used to restore registered settings to the camera defaults.

Drive Modes and Focusing

Now that you are familiar with the G10's controls and menu settings, we will show you how to apply this knowledge and the camera's capabilities to get the best possible pictures. After all, that's what it is all about! So let's start shooting.

Drive Modes

In the days of film cameras, drive modes controlled how the shutter was fired as film was advanced through the camera. While today's digital cameras no longer transport film, they do still fire the shutter, recording either one single image or a sequence of images.

To select Single Shot and Continuous drive modes, depress the ⧉ ⟳ button on the bottom of the four-way controller (same as the down controller key). Scroll up and down the icons in the column that appears in the LCD using the controller keys or Control dial. Press ⌨ to confirm your choice.

■ Single Shot

In this default mode, the G10 captures a single image with each press of the shutter button. This is probably the drive mode that is used most often, especially when taking pictures of stationary subjects or scenes.

The Continuous Shooting AF drive mode is a helpful choice to capture the peak of action when shooting sporting events. The camera maintains focus and records consecutive photos as your subject moves through the frame. Photo © Kevin Kopp.

Continuous Shooting Modes

In these modes the camera fires continuously while the shutter button is held down. Framing rates vary depending on such factors as shutter speed in use, memory card write speed, and whether the card is close to its memory capacity. The different continuous drives are:

■ **Continuous:** This drive allows you to shoot with a fixed focus at 1.3 frames per second (fps). (In this case, fixed focus means that focus will remain locked on the point of focus in the first frame.)

■ **Continuous Shooting AF:** The camera will continue to autofocus while recording successive images, but only at 0.7 fps. This mode cannot be used in manual focus.

■ **Continuous Shooting LV (Live View):** This is the only way to shoot continuously with manually selected fixed focus (once set, focus is locked). To select, press the **MF** button on the top of the four-way controller (same as the up key) to select manual focus before pressing the ■ ◌ button and use the up/down arrow buttons to select ■ . Alternatively, press the **MF** button after the mode has been selected—it will automatically switch to, and display, this icon at the top of the LCD screen.

Autofocus (AF) Mode

The PowerShot G10 sports a large number of autofocus options, including an impressive Face Detection system. Autofocus is the default mode and the camera focuses automatically unless set for manual focus. Set either [Single] or [Continuous] options using the ■ menu in the [AF Mode] item. In Single AF mode, the camera focuses when the shutter release is depressed halfway, locking focus at that point. In Continuous AF, the camera focuses continuously on whatever it is aimed at, whether the shutter button is pressed halfway or not, and even as you move the camera to follow a moving subject. This allows you to

Consider your composition when choosing an AF Frame mode. If the part of the scene you want to focus on is off-center, you'll want to use the AiAF or FlexiZone modes so you can reposition the point of focus. Photo © Jeff Wignall.

shoot at any time without missing opportunities (but it also consumes more power).

Note: Continuous AF is not available when the AF Frame mode is set to [AiAF] (see next page).

AF Frame Mode

The AF frame controls the part of the scene on which the camera focuses. To select an AF Frame mode, press the ⬚ button, and then press the ✳ button (back of camera, upper right corner) repeatedly to cycle through the options. To execute the setting, press ⬚ again. You can also select AF Frame modes in the ▣ Menu. The Power-Shot G10 offers four AF Frame modes:

☐ **Center:** The AF frame is in the center of the frame. This can be set only when the **AUTO** and **SCN** Shooting modes are active. It is useful when focusing on stationary subjects, especially if they are close to the middle of the frame.

⊞ **AiAF:** The camera automatically selects the AF area among nine possible zones laid out in a rectangular grid within the frame, focusing on a subject that may not be in the center of the scene.

Note: The G10 allows you to alter the size of the AiAF area to match the size of the subject or specific details you wish to focus on, making the entire area smaller or larger. Highlight the AiAF area in green by pressing ⚏ . Then toggle between the two sizes by pressing ⊙ . Press ⚏ or ⊙ to activate your setting. When the digital zoom, digital teleconverter, or manual focus is in use, the frame size reverts to normal.

⸢ ⸣ **Face Detect:** This is one of the newer, innovative digital camera features. In Face Detect, the camera automatically focuses on a face if one is in the frame. When Evaluative metering mode (▣) is in use, Face Detect will also optimize exposure for the face. When the flash is in use, Face Detect correctly lights the face. This is the default for the **AUTO** and **SCN** Shooting modes. (See also page 126.)

⊹ **FlexiZone:** This is the default for the **P** , **Tv** , **Av** , and **M** Shooting modes. It allows you to move the AF frame and place it anywhere you wish within the scene so that, for instance, you can focus on a tree that may be on a hill high to the left, or on a flower in the lower right corner. Or if a single subject fills most of your frame, you can focus on a precise part of the subject. You can also change the size of the FlexiZone after highlighting the mode with ⚏ and then toggling with ⊙ . Press ⚏ or ⊙ to activate this change.

Note: If the LCD screen is turned off, only AiAF and Center modes are available. If Face Detect has been set, the mode will change to AiAF; if FlexiZone had been set, the mode will change to Center. The AF frame display is green when the subject is in focus. It will appear yellow if there is focusing difficulty when Center or FlexiZone is set, and no AF frame appears if the camera is unable to focus with the Face Detect or AiAF options selected.

Moving the AF Frame

The AF frame can be manually repositioned in FlexiZone mode, allowing you the ability to focus on any part of the scene. The frame can also be moved in AiAF, but only when the small size frame is in use.

After selecting FlexiZone or AiAF, the focus frame will display in green. To move the green frame, rotate the Control dial or press the four-way controller keys to position the frame where you wish, and set by pressing ⓢ . To move the AF frame back to its original (center) position, hold the ⊞ button down for a couple of seconds.

When the camera detects faces in the AiAF mode, each press of the MENU button moves the frame to a different face. Also in AiAF mode, the nine-area display in green is displayed as white AF frame brackets when you activate your setting.

The AF frame cannot be moved in manual focus (MF) mode. If the camera's power goes off and/or the lens retracts in Playback mode, the AF frame returns to the center.

Note: When shooting in FlexiZone, you can choose to make the AF frame the metering area, too. First, select the Spot metering mode ▣ . Then go to the ◉ menu, scroll to [Spot AE Point], and use the left/right controller keys to choose [AF Point].

Servo AF—Focus Tracking

In Servo AF mode, as long as the shutter release is pressed halfway, the camera will focus on the subject even if it is in motion. You can then track the subject as it moves and press the shutter button when you are ready, making it easier to successfully photograph a moving object. Note that this mode does consume more battery power.

Activate [Servo AF] in the ▣ Menu. The camera will track focus on the subject that is framed by a blue rectangle in the LCD, whether that be a face when the AF Frame is set to [Face Detect], or some other object when a different AF Frame is in use. Focus remains on the subject within the blue AF frame for as long as the shutter release is depressed halfway.

Note: Servo AF is not available when the AF frame is set to AiAF, when the Drive is set to FaceSelf-Timer 🖼 , or when the focus is set to **MF** .

The Face Detect Feature

When Face Detect is enabled, up to three faces in the scene will be surrounded by AF frames on the LCD. The camera selects one face (if there is more than one in the picture), which it determines is the main subject. That face will be surrounded by a white frame, while the other faces appear in gray frames. The frames will even move to follow the faces if people shift positions within the frame. When you press the shutter button halfway to autofocus, up to nine green frames may appear.

Note: If a white frame fails to appear—all the frames remain gray, or if a face is not detected—images will be shot in AiAF mode when Single AF is selected and in Center mode when the camera is in Servo AF or Continuous AF. The G10 may occasionally identify non-human subjects as faces, and may not be able to identify faces that are at the edge of the screen, or are partially obscured, etc.

When the Face Detect autofocus mode is selected, the G10 will frame up to three faces in the scene and automatically focus on the one it determines to be the main subject. You then have the option to manually select any of the other faces as the main subject. Photo © Kevin Kopp.

To use this function, press the ⊞ button while faces are detected by the camera (frames appear on the faces on the LCD). The white frame around the main face now displays a double-cornered frame that will follow the subject within a certain range, even if the subject moves. The frame will not appear when a face is not detected. The double-cornered frame for the main subject will change to a single white full frame when you press the shutter button halfway, and will turn yellow if the camera has difficulty focusing.

When several faces have been detected, you can also select a specific face on which to focus. Press the left controller key or turn the Control dial to move the face frame to another subject. Holding down the ⓓⓘⓢⓟ button for one second will display up to 35 face frames for all of the detected subjects—a green frame around the main face and white frames around other detected faces. Press the shutter release down fully to take the shot.

To exit, press the ⊞ button again and the double-cornered frame will change to white, and the frame will continue to track the subject if it is within range. Pressing the button once again will release the Face Detect mode.

Note: Face detection will be cancelled under the following conditions: when the camera has gone off and is turned back on, after switching to another Shooting mode, when using the digital zoom or digital teleconverter features, after pressing MENU and displaying the menu screen, when the LCD display is turned off, and when a selected face cannot be tracked for several seconds.

Zooming to Check Focus
You can view an enlarged section of the image on the LCD while composing your photo. This makes it easier to check focus and facial expressions. When the AF Frame mode is set to any choice other than AiAF, the camera will zoom in on the image within the AF frame. Activate this function in the ▣ Menu by selecting [AF-Point Zoom] and scrolling to [On]. Aim your camera and hold the shutter button halfway

to see the enlarged portion of the AF frame. Continue pressing the shutter button all the way to record the shot.

When the AF frame mode is on [Face Detect], the camera will zoom in on the face it determines is the main subject. When the AF frame is set to [Center], the middle of the frame will appear larger. When [FlexiZone] is set, the area in the user-selected AF zone will be zoomed in.

Note: You cannot set [AF-Point Zoom] if Servo AF is active. The AF frame cannot be zoomed in [Face Detect] mode when no face is detected or if the face is an extremely large part of the overall composition. In addition, the zoom will not function when the camera cannot focus (the bottom LED blinks yellow), when digital zoom is in use, or when a TV is being used as the display.

Shooting Hard-to-Focus Subjects

The G10's high performance AF system normally does an outstanding job, even under challenging conditions (e.g. with low-contrast subjects in low light), but all AF systems have limitations. The camera provides four methods of dealing with hard-to-focus subjects—Focus Lock, AF Lock, manual focus (MF, see page 132), and Safety MF (see page 134).

Shooting with Focus Lock: If the camera cannot focus on the subject, try locking focus on a surrogate object. Find something that is the same distance from the camera as the subject. Center the substitute subject in the viewfinder or AF frame on the LCD screen, then press and hold the shutter release halfway to lock focus on the subject as you recompose the image, pressing the shutter button in fully to take the shot.

Shooting with AF Lock (AFL): Use the procedure described above, but while focusing on the surrogate subject press the **MF** button (the up controller key) as you depress the shutter release halfway. Now recompose the picture as you want it, and shoot. The advantage of this method is that you can lock the focus setting without maintaining pressure on the

shutter release while you compose the picture. Also, the AF lock is still effective even after you take the picture, allowing you to shoot additional images at the same focus point. To release the AF lock, press the **MF** button again. AF lock cannot be set when [Servo AF] is turned on.

Note: You cannot use this method in the Stitch Assist ⊡ Shooting mode. However, you can assign the [AFL] option to the [Set Shortcut button] item in the ⊡ Menu. Then simply press the Shortcut button (⌼) in the Stitch Assist mode to lock focus. Also, since the AF frame does not appear in ⊡ and ⊡ modes, be sure to point the camera directly at your intended subject. When using either of the above methods, it is best to set the AF Frame mode to [FlexiZone] or [Center] so that only one AF frame is active. (For more information, see page 124.)

Focus Bracketing Mode

In this mode, the camera automatically takes three successive photos when you press the shutter button: one at the manual focus position you set, another at a focus position farther than the manually set focus point, and a third at a position that is closer than the manually set focus point. The distance between the set focus and the farther and nearer focus points can be set for three different intervals—Large, Medium, and Small. Focus Bracketing mode is not available when shooting with the flash on—only one image at the manually set focus point will be recorded.

Focus Bracketing is set in the FUNC. Menu. After setting the interval for the near and far focus points by confirming with ⊛ , manually focus on the subject. Then shoot the image and the focus bracket will be recorded. To cancel, highlight ⊞ in the FUNC. Menu and press ⊛ .

Note: Focus Bracketing cannot be used when recording in Movie ⊡ mode.

*Use Macro mode when you want to shoot small items up close.
Photo © Kevin Kopp.*

🌷 Macro Mode

Move the camera close to small and detailed items by pressing the Macro button 🌷 (left controller key) to allow sharp focusing on objects from as near as .4 inches (one cm) to 20 inches (50 cm) from the lens. A 🌷 and 🏔 icon will appear in the LCD. Scroll to highlight 🌷 . Use the Zoom lever to display a zoom bar at the top of the LCD that gives you approximate focusing distances, and shoot when you have achieved sharp focus. You can exit this mode by pressing the 🌷 button again and scrolling to highlight the 🏔 icon.

Most compact digital cameras don't offer a manual focusing mode. The G10's manual focusing allows you to explore creative techniques beyond what autofocus can deliver. Photo © Jeff Wignall.

MF Manual Focus Mode (MF)

In addition to a wide variety of autofocus features, one of the G10's most useful and distinctive features is its convenient, fully articulated manual focus mode, which is not usually found in digital compact camera.

To use manual focus, make sure the LCD screen is displaying, and press the **MF** (up) key on the four-way controller. A large **MF** logo briefly appears in the center of the LCD screen and this soon changes to a small icon with directional arrows near the lower right corner of the screen. A distance scale along the right edge will also display. You can set the focusing distance manually by turning the Control dial, but the vertical bar graph scale (MF indicator) only shows approximate values to be used as a general guide.

Use manual focus when you want complete control over the focused areas of your images. Here, manual focus was used to get in close to ice crystals formed on a window. Photo © Matt Paden.

To focus more precisely in MF mode, press MENU and select the 🔘 Menu. Scroll to [MF-Point Zoom] and select [On]. In the same menu, if [AF Mode] is set to [Single], you can now press the shutter release halfway (or MENU) to set your selections and leave the menu system. A magnified portion of the preview image in the LCD frame will display, facilitating manual focusing. Rotate the Control dial to adjust focus. The magnified focusing image will continue being displayed until you take the shot, select another mode, or press the **MF** button again to leave manual focus mode. You can zoom in to check details for increased focusing precision, and then zoom back to compose and take the shot.

When MF is active and the AF Mode is set to [Continuous], the magnified portion of the preview will only display while you turn the Control dial (e.g., it is not displayed auto-

matically). The position of the magnified zone in the LCD is variable, depending on the AF frame selection. When [AF Frame] is set to [FlexiZone], the location of the frame that is set immediately prior to setting MF will be magnified. When set to modes other than [AiAF], the location of the magnified portion is at the center of the LCD screen. When using digital zoom, digital teleconverter, or displaying the image on a monitor/TV, [MF-Point Zoom] is not available. You cannot change the AF Frame mode while in manual focus mode—first cancel MF and then change the AF Frame mode.

Manual Focus Plus AF

Another way of achieving accurate focus using MF is to focus approximately in MF mode, and then employ the camera's AF system to focus more precisely. There are two methods to achieve this. The quickest way is to first focus normally in MF mode and then press the ⊞ button. The camera will beep and adjust to a more accurate focus point. Alternatively, you can set [Safety MF] in the ⬛ menu to [On]. Now focus using MF, then press the shutter button halfway and the camera will automatically find a more accurate focusing point.

Use Manual Focus Plus AF when you want to focus on parts of a ⇨ *scene manually, but still want the extra backup of the camera's AF system to make sure those subjects are sharp. Photo © Kevin Kopp.*

Exposure, White Balance, and In-Camera Adjustments

Exposure

In digital photography, exposure refers to the amount of light that strikes the sensor. This is primarily controlled by the combination of lens aperture and shutter speed.

The aperture is the opening in the lens, often described as an f/number. The opening can be set to vary from wide (low f/number, e.g. f/2.8) to narrow (large f/number, e.g. f/16). Naturally, a wide opening allows more light in than a narrow opening. Each successive f/stop on the camera usually doubles or halves the quantity of light, so that f/4.0 allows twice as much light as f/5.6, but only half as much as f/2.8.

The camera's shutter can be timed to be open for a certain duration. A short or fast shutter speed (e.g. 1/500 or faster) permits less light than a long or slow speed (1/15 second, or longer).

A third factor also comes into play, namely the ISO setting. ISO is a control that electronically boosts the sensor's reaction to light, so that faster shutter speeds or narrower apertures can be used at higher ISO settings (see pages 45 – 46 for additional information and ISO setting instructions.)

🖙 *Since the G10 is as sophisticated as many D-SLRs, it allows photographers to choose many of the settings that create a good exposure. It also has options for adjusting images after capture, which is a nice feature many D-SLRs don't offer.*

A photographer's job is to use the camera, its controls, and its accessories to allow the correct amount of light to pass through the lens to produce the intended type of color, tone, and contrast. There are a number of functions and techniques that help accomplish this.

Metering

The G10's metering system does its job remarkably well. However, sometimes a "good" automatic exposure from the camera isn't actually the best exposure for the subject. Plus, digital cameras have a tendency to overexpose bright areas because they have a response to light that is similar to traditional transparency (slide) film. To get an exposure that truly expresses your creative intent, there are things you can do to transform a good exposure into the great image you want. One of these is selecting the metering pattern or mode so that you can achieve the best exposure for the subject. To select the metering mode, press the ◉ button (on the back of the camera, above and to the right of the Control dial) while in the Shooting mode, then rotate the Control dial to make your selection. The icon for the mode you've selected will appear at the bottom of the LCD screen, slightly to the right of center.

◉ **Evaluative Metering:** This sophisticated system is the best choice for the majority of subjects you will record, used for most general shooting. It gathers data by metering various areas of the frame. The camera's microprocessor evaluates this data and compares it to computer exposure models. When [Face Detect] is selected (an option within the [AF Frame] item in the ▣ Menu), this metering mode gives added weight to facial areas in determining the correct overall exposure. However, with Evaluative metering, you won't know in advance how the camera will render the picture, so if you want to achieve a specific creative effect in part of the scene, Spot AE Point metering may give you results that are closer to the effect you are trying to achieve.

Using Evaluative metering is often the best approach, especially in complicated lighting situations like the one pictured here. Because the edge of the porch is brighter than the parts under the roof's shadow, Evaluative metering is a good choice to get an accurate reading of the light from all parts of the picture frame. Photo © Jeff Wignall.

◨ **Center-Weighted Avg.:** This metering pattern averages the light in the entire scene but places extra weight on the area in the middle. In my opinion, this is not the best choice in metering patterns. Unless you have had cameras with this type of metering in the past and are thoroughly familiar with the results you will get, I recommend that you use one of the other metering types.

◙ **Spot AE Point:** This meters the area within the AF frame. It is very precise and will give you better results than with the other patterns if you want to meter a specific area of the scene. It is a great choice when there is a big difference between your subject and the rest of the scene (such as a person in front of bright backlighting or a white flower against a dark background).

When using Spot AE Point metering, you have the choice reposition the AE point that is used to meter. This is invaluable because it allows you to target the part of the frame that you want to meter. In the ⬛ Menu, select [FlexiZone] in the [AF Frame] item. Then scroll down to the item for [Spot AE Point] to select an option:

- **Center Point:** The camera meters the central focusing point in the middle of the frame.
- **AF Point:** The AF area in use, which can be moved within the frame, becomes the metering spot. (See page 79).

Exposure Compensation

For most photographic situations, the camera's metering system offers excellent exposure. Problems occur when the scene or subject is mostly very dark or mostly very light. Other situations that may give the camera's meter a problem occur when there is extreme contrast in the scene (such as glare from snow or sand), or when a bright light (like the sun) shines into the lens (backlighting), especially when it is near an AF focusing point. Once you understand how your meter reacts to light, you can use the exposure compensation feature to make a quick adjustment and continue to shoot automatically.

Setting exposure compensation to a positive (+) value makes an image lighter and can be used to avoid underexposure of a backlit subject or when shooting against a bright background. Setting the exposure compensation to a negative (–) value makes the image darker, and is useful in preventing overexposure of bright lights in a night scene or when shooting subjects against a dark background.

Use the exposure compensation dial located on top of the camera to the left of the hot shoe to set the exposure compensation in 1/3-stop increments (to +/– 2 stops). If exposure compensation is available in the selected shooting mode, the exposure compensation index lamp will light orange; it will not light in **AUTO** , **M** , or ▣ Shooting modes. If any value other than 0 is set, the exposure compensation

scale will appear on the LCD screen for a few seconds; all exposure compensation settings, including 0, will be displayed in white in the upper left corner of the LCD. To cancel exposure compensation, turn the exposure compensation dial to its 0 setting. When applying the Autoexposure Bracketing mode (AEB, see next topic), the compensation range for AEB shooting is displayed.

▣ AEB (Autoexposure Bracketing) Mode

In this mode, the camera automatically shoots a sequence of three consecutive images—one at the standard metered exposure, an underexposed image, and an overexposed one. The amount of under/over-exposure deviation from the standard exposure on the last two images can be set in 1/3-stop increments up to +/- 2 stops.

Set AEB in the FUNC. Menu (see page 66). Display the AEB exposure deviation scale at the bottom of the LCD screen to adjust the compensation range (exposure deviation). To cancel AEB mode, highlight ▣ in the FUNC. Menu.

✱ AE Lock

Locking exposure on the subject or another part of the scene is another method of controlling or adjusting the exposure. You can set and lock the exposure separately from focus, which is an effective technique when the contrast between subject and background is strong or when the subject is backlit. Be sure to set the flash to ⊛ (press the ⚡ key—same key as right controller—and scroll) when using AE Lock so it does not fire. (For locking exposure when using the flash, use FE Lock—see page 179.)

To set AE Lock, turn the LCD display on and aim the camera at the subject on which you wish to measure exposure. Press the ✱ button (on back of the camera, in the upper right corner). The exposure will lock and ✱ will display in the LCD. Now recompose the frame and take the shot. To release AE Lock, press any button other than the ✱ button.

Exposure lock is a way to quickly compensate for problem scenes. For example, suppose you were shooting a sunrise, but the scene included a dark rocky area in the center of the scene, which the camera focused on. That large dark area connected to the focus point would likely throw the meter off, resulting in a pale, washed out sunrise (from too much exposure).

To adjust for this, you can move the G10 so it sees more sky and less rock, and lock the exposure when you see the color in the sky improve in the LCD. Next, reframe the picture like you wanted it in the first place using the locked-in exposure settings. The picture you take should now show more accurate colors in the sunrise.

Exposure Modes—Get in Control
While the scene specific modes (**SCN** , see pages 148 – 149) are useful for photographers who are not experienced with the G10, you will gain more control over all aspects of the photo by using P, Tv, Av, and M modes. These exposure modes allow you to control some of the many aspects of photography, depending on which one you set on the Mode dial. The best way to become acquainted with these controls is to take and review a lot of pictures—and digital cameras make this easy and affordable. Here are some tips for making the most of these creative modes.

P **Program AE Mode:** When the Mode dial is set to **P** , the camera automatically sets both the aperture and shutter speed to provide a correct exposure based on the brightness of the scene. However, the **P** mode offers more flexibility than the **AUTO** mode. For example, unlike **AUTO** , you can set the ISO speed, exposure compensation, and white balance, and you can shoot RAW as well as JPEG images.

When a correct exposure cannot be obtained, the shutter speed and aperture values are displayed in red on the LCD. To remedy this problem in low light, use the flash or increase other available lighting, adjust the ISO speed set-

The Creative Zone exposure modes offer you the opportunity to express your photographic creativity, from controlling depth of field to stopping motion to intentionally under or overexposing your photos. You can learn how to produce a number of effects by experimenting with these exposure modes. Photo © Matt Paden.

ting, or set the [Auto ISO Shift] to [On] in the ⚫ Menu (also see page 79). If the light is too bright, you can adjust the ISO speed setting (it may be set too high), use Auto ISO Shift, or set the built-in ND filter to [On] (see page 68 for information about setting the ND filter).

The G10 also offers the ability to shift the shutter speed and aperture settings while maintaining an equivalent exposure. This is possible because each change in shutter speed or aperture either doubles or halves the amount of light reaching the sensor. If you open the aperture one stop and decrease the shutter speed one stop, the amount of light reaching the sensor will remain the same. This is called Program shift.

Program Shift: Press the shutter button halfway and then press ✳ to lock the exposure setting. An arrow will be displayed to the left of the shutter speed value and to the right of the f/stop value. If these arrows are green, you can rotate the Control dial to change the combination while maintaining the equivalent exposure. The locked exposure setting will cancel after each shot is taken.

Tv Shutter Speed Mode: This mode is often referred to as Shutter priority mode. When the Mode dial is set to **Tv**, you choose the shutter speed and the camera automatically sets a corresponding aperture that will provide a correct exposure based on the scene brightness. Fast shutter speeds allow you to freeze the action of a fast-moving subject, while slower shutter speeds can create a flowing or motion blur effect with moving subjects (like a waterfall). Slow shutter speeds also allow you to shoot without flash in low-light conditions because a longer duration of light is exposing the sensor. When you use the Control dial to change shutter speeds, a Tv scale will appear on the LCD screen that lets you select your desired shutter speed. A window below the bar will show your selected shutter speed along with a green double-arrow graphic indicating that you can turn the Control dial in either direction to select other shutter speeds. You can also change the combination of shutter speed and aperture without altering the exposure by pressing ✳ to lock in the exposure, then turning the Control dial to select any shutter speed/aperture combination you wish to use.

If the aperture value appears in red on the LCD screen when you press the shutter halfway, it is a warning that the photo may be under- or overexposed at the current shutter speed. Use the Control dial to select a slower or faster shutter speed until the aperture value appears white. Or turn on [Safety Shift] in the ⚪ Menu (also see page 79). When Safety Shift is on, the shutter speed and aperture in **Tv** and **Av** modes are automatically adjusted to provide a correct exposure. Safety Shift is disabled once the flash is turned on.

Use the Creative Zone modes to have control over your images. Here, a fast shutter speed was selected in Shutter Speed Mode to stop the motion of the flags waving in the wind. Photo © Kevin Kopp.

Note: Due to the inherent characteristics of CCD image sensors, noise in the recorded image increases at slow shutter speeds (long exposures). In such cases, the G10 uses special processing to eliminate noise and produce high-quality images, which can occasionally delay the camera from taking the next image while processing occurs.

Av Aperture Mode: This is commonly known as Aperture priority mode. When the Mode dial is set to **Av** , you set the aperture value and the camera automatically sets the shutter speed to provide a correct exposure based on the scene brightness. Selecting a lower f/number (like f/2.8) opens the aperture wide and allows you to blur the background of an image by decreasing the depth of field. (This is

best used in conjunction with a close focusing distance on your subject.) Setting a high f/number like (f/8) makes the aperture opening narrow and provides greater depth of field, bringing both the foreground and background into focus (which is ideal for landscapes).

When you use the Control dial to change the aperture value, an Av scale appears on the LCD screen along with a window that shows the current aperture value. A green double-arrow icon indicates that the Control dial can be used to raise or lower the aperture value in use. Press the shutter release partway and the camera-selected shutter speed corresponding to your aperture value will appear to the left of the aperture readout. If the shutter speed is shown in red, use the Control dial to adjust the aperture value until the shutter speed numerals turn white, thus achieving a correct exposure.

In general, the available apertures are: f/2.8, f/3.2, f/3.5. f/4.0, f/4.5, f/5.0, f/5.6, f/6.3, f/7.1, and f/8. However, some aperture values are not available at the maximum wide-angle or maximum telephoto positions. As with Shutter Speed mode, you can change the combination of shutter speed and aperture settings without altering the exposure by pressing the ✖ button to lock the exposure and rotating the Control dial to select the shutter speed/aperture combination you wish to use.

M **Manual Mode:** Setting the Mode dial to **M** allows you to manually set both the aperture and shutter speed to control the exposure. A vertical exposure level scale appears on the right side of the LCD screen so you can adjust the exposure to match the camera-suggested exposure (by turning the Control dial to align a movable dash mark with the centerline of the index, marked in green), or deliberately over- or underexpose the image by setting the index mark over or under the centerline in 1/3-stop increments. To switch back and forth between setting apertures and shutter speeds (i.e. to activate the exposure variable you wish to change) press the 🔘 button repeatedly until the variable

you want to use is highlighted in gray and displays green control arrows below the numerical readouts.

The active scale cycles through shutter speed, aperture, and metering pattern icons as you press the [⊙] button, so you can easily reset the meter pattern in use if you wish. If the current exposure dash along the right edge of the metering index appears in red, then you know the difference between the set exposure and the camera-calculated correct exposure is greater than +/- 2 stops (+2 stops if the red dash appears at the top of the scale, -2 stops if it appears at the bottom of the scale). When you press the ✳ button, the shutter speed or aperture will automatically shift to obtain the correct exposure—except when the MF and [⊙] icons are selected. The aperture will change if the shutter speed scale is selected and the shutter speed will change if the aperture scale is selected. If you press the ✳ button after you have adjusted the exposure compensation, the exposure will shift to the adjusted value and this value will appear as a green line on the exposure level scale.

If you zoom the lens after the exposure values are set, the aperture or shutter speed value may change to adjust for a change in brightness in the scenic area that is now in the frame. The brightness of the LCD monitor matches the shutter speed and aperture readouts. When you select a fast shutter speed or shoot in a dark place, set the built-in flash to ⚡ mode or use an externally mounted flash.

The Scene Modes

The aptly named Scene modes are fully automatic exposure modes with the camera setting different shooting attributes depending on the type of scene selected. For instance, the camera will automatically set the drive mode to Continuous Shooting AF when Sports 🏃 is selected, or apply vivid greens and blues when Foliage 🍂 is selected.

Set the specific mode you want by pointing the Mode dial to **SCN** and turning the Control dial until the desired icon and its description appear in the LCD.

👤 **Portrait:** The camera yields a softer focus for portraits.

🏔 **Landscape:** Depth of field is maximized to keep both near and far objects in focus.

🌃 **Night Scene:** To take nice people pictures against a night time scene, the flash illuminates your subject while the shutter speed is long enough to record ambient light in the background. Make sure to set flash to ⚡ and use a tripod.

🏃 **Sports:** Set this when the subject is moving. The camera uses Continuous Shooting AF and a fast shutter speed.

🌙 **Night Snapshot:** Allows you to shoot in low light by applying image stabilization and wide aperture settings.

🧒 **Kids & Pets:** Similar to Sports settings, allowing you to capture kids and animals on the go.

🏠 **Indoor:** Applies stabilization and white balance adjustments to record in indoor light.

🌅 **Sunset:** Enhances the red, yellow, and orange colors.

🍂 **Foliage:** Saturates or enhances the colors of trees and leaves.

❄ **Snow:** Minimizes overexposure and sets white balance to neutralize blue color cast.

🏖 **Beach:** Adjusts white balance to bright sun, reduces high contrast so people do not appear dark in strong backlighting.

🎆 **Fireworks:** Increases depth of field and decreases shutter speed. Optimizes bright color exposure against dark background. Use tripod.

Aquarium: The optimal white balance and ISO are set to match the environment and lighting of an indoor aquarium.

Underwater (only use camera with waterproof case WP-DC28 when shooting underwater): Reduces flash and adjusts white balance for underwater conditions.

ISO 3200: Sets ISO 3200 and increases shutter speed. Recording pixels set to [M3] .

Color Accent: see page 155.

Color Swap: see page 156.

White Balance (WB)

Although we don't always perceive it, light can have different color temperatures (as measured on the Kelvin scale). Daylight varies from the warmth of sunrise to the blue of shadows, and artificial light can be yellowish to greenish depending on the source. The Kelvin (K) temperature range that we commonly deal with in photography is approximately 2500 – 10000 Kelvin (K). Lower temperatures on the scale are warmer, with a more orange/yellow cast than higher temperatures, which are bluer. Though our brains interpret these colors so they usually look natural in a scene, the camera records the different color sources objectively. Without proper white balance, a tungsten-lit room (approximately 3200K) records with a yellow cast, while a photo taken outside under dark, overcast conditions (approximately 6500K) will have a bluish cast. White balance is a photographic tool to neutralize these color casts, and can be applied to both still pictures and movie recordings in the G10.

To record accurate color, the camera's white balance setting should match the source of the light in which you are shooting. The Auto setting [AWB] generally yields natural-looking colors under a variety of common lighting conditions, but when it does not, the G10 provides a number of specific settings to obtain more accurate results. You can also perform what is called Custom white balance.

Even if you shoot outside, the white balance (or color temperature) of light changes constantly throughout the day. Change your white balance settings often to reflect the available light, or even try experimenting to see if a different choice yields a better result. For example, the Cloudy WB setting often warms the colors of an image. Photo © Kevin Kopp.

For example, if you are outside in the mid-day sun (approximately 5200K), you want to match that lighting and color condition to the camera's setting for Day Light ☀ . In that circumstance, if you set the camera's white balance for Cloudy ☁ , the resulting image will be uncharacteristically yellow or orange (the camera warms the image up because it is being told that the scene is cooler). Or if you then set the white balance to Tungsten 💡 , the image will look somewhat blue (the camera is being told that the scene is warmer than it really is, so it balances by cooling the image).

Note: The white balance setting cannot be adjusted when [Sepia] or [B&W] is selected for My Colors, or in Stitch Assist Shooting mode.

The white balance on the G10 is set in the FUNC. Menu (see page 63). You can see the effect that each white balance setting will have on the image by scrolling through the WB options as you preview the scene on the LCD (this does not work when viewing through the optical viewfinder).

Auto: The camera will determine the WB setting automatically. Use this in situations where there are mixed lighting sources and/or you are not sure what setting to use.

Day Light: Set this when you are recording outdoors on a sunny day.

Cloudy: Use this setting when you are outside but under darker than sunny conditions, such as cloud cover, shade, or setting sun.

Tungsten: This setting is for use when you are under light cast by household incandescent light bulbs.

Fluorescent: Set this if the scene is illuminated by warm-white or cool-white fluorescent lighting.

Fluorescent H: For shooting under daylight fluorescent lighting.

Flash: Use when you are using flash to light the scene.

Underwater: Use this setting if you shoot under water.

Caution: If using the G10 for underwater photography, the camera must be placed in a special underwater case, WP-DC28, which must be purchased separately.

/ **Custom 1 and Custom 2:** Though this involves more steps than other white balance options, Custom is the most precise way to set white balance in the G10 for the existing lighting conditions. So if you are faced with unusual lighting, or none of the other WB settings yields natural-looking color, or you are simply unsure what the color temperature of the scene is and want to render the color as

accurately as possible, try setting a Custom white balance (see page 64 for details on how to do this). You can store two separate Custom WB settings in the camera.

Custom White Balance Tips

It is best to set the Shooting mode to **P** and the exposure compensation setting to 0 before making a Custom WB reading, so that exposure discrepancies will not influence the results. When taking a close-up white balance reading using flash, the exposure may be off, causing an erroneous white balance reading. If this happens, try taking the reading at a greater distance from the white target. When using a Custom WB setting, make sure to take the shot at the same camera settings used to make the Custom reading—if other settings are used, optimal white balance may not be obtained. In particular, do not change the ISO setting. White balance settings cannot be made in Stitch Assist mode; use another shooting mode. White balance data is retained when the camera is turned off.

In-Camera Adjustments

As mentioned in Chapter 1, the G10's impressive Digic 4 image processor does an excellent job of turning the camera into a miniature computer, complete with selective tone and color effects that can be applied directly to captured images, customizable settings, and file organization features. You can set a number of handy functions before shooting to add particular types of enhancements to the images you record.

i-Contrast

Set i-Contrast in the ▣ Menu. When [Auto] is selected, the camera will automatically detect faces and dark areas, compensating for brightness levels while shooting to control excessive contrast in the captured images. This correction will only be applied to JPEG files, not affecting the RAW files when the RAW+JPEG recording option is selected, and cannot be used when the camera is set for RAW capture only.

Use the ND filter to lessen the amount of light hitting the sensor under very bright conditions. Photo © Kevin Kopp.

Note: Depending on the scene, the i-Contrast compensation you set may not always yield the expected result. You can also use the i-Contrast setting in the Playback Menu to apply brightness compensation to images already captured (see page 108).

⬛ Neutral Density (ND) Filter

The ND filter built into the G10 reduces the intensity of incoming light by 3 stops (or 1/8 of its value). This is useful for enabling slower shutter speeds or wider apertures to be used, or can be helpful if the correct exposure cannot be obtained in bright situations. However, since this can lead to slower shutter speeds, a tripod is recommended when recording with ND selected.

The ND filter feature is activated in the FUNC. Menu. To cancel the setting, highlight ⬛ .

My Colors

This function allows you to vary the way a JPEG image will look—particularly in terms of hue, tone, or saturation—as the camera applies a degree of image processing to the image file. As with white balance, you can see the effect of each setting as you scroll through them while previewing the scene on the LCD, though some of these settings are subtler and more difficult to recognize than others.

There are a number of choices available. Make your selections for different My Color settings in the FUNC. Menu.

Off: No enhancement is applied to the image file.

Vivid: Added saturation and contrast produces colors that are more intense and strong than normal recording.

Neutral: Reduces saturation and contrast so that colors are not so bold.

Sepia: Produces a sepia-tone image (a faded brown look that sometimes resembles old-time photographs).

B/W: This setting records a black-and-white photo.

Positive Film: Blues, greens, and reds are somewhat saturated to stand out but still appear natural, like colors obtained using positive film.

Lighter Skin: This will render skin tones lighter.

Darker Skin: This renders skin tones darker.

Vivid Blue: Emphasizes blue tones in the scene, making them more intense.

Vivid Green: Stresses greens in a scene, making, for example, grass, leaves, and general landscape scenery more vivid.

Vivid Red: This strengthens reds in a scene so they are bolder and more intense.

Custom Color: This option allows you to adjust the level of Contrast, Saturation, Sharpness, and the color intensity of Red, Green, Blue, and Skin Tone in a scene.

Note: My Colors cannot be applied when recording in RAW format. However, like i-Contrast, this feature can also be applied in Playback mode to images that are stored on your memory card (see page 110).

All of the red elements in this scene remain red using the Color Accent adjustment, while everything else was converted to black and white. Photo © Kevin Kopp.

Changing Colors in Captured JPEG Images

Two special effects can be applied to in-camera color processing, enabling a Color Accent or Color Swap special effect. These two functions are actually two selections in the Shooting mode, both found as options in the **SCN** mode or in the 🎬 mode. (Be aware that you may not get expected results using flash.)

🎨 **Color Accent:** An image is produced so that only one specified color remains in the photograph or movie, converting the rest of the image to black and white. To activate this feature, first point the Mode dial at either **SCN** or 🎬 . Then rotate the Control dial to select 🎨 (still photos) or 🎨 (movies). Press 🔘 and aim the camera at your

scene so that the color you wish to retain as an accent fills the small frame displayed in the center of the LCD screen. Now press the left four-way controller key to cause the accent color (or one close to it) to appear in the color adjustment display at the bottom of the LCD. Use the up/down controller keys to select a value (integers from +/–5) to specify the range of colors that are retained. At the –5 setting, only the specific color you want is kept as an accent in the photo; at the +5 setting colors close to the one you set are also retained and accented. Press ⊛ to complete the setting. All portions of the image within the specified color and range will remain in the picture, while the rest of the photo becomes black and white. The specified color accent and range settings are retained when the camera is turned off.

Note: You may not always get the results you expect when using flash. Depending on the shooting conditions, the image quality and color may sometimes be different than desired. Before shooting important pictures, take trial shots and confirm the results.

⛀ **Color Swap:** As its name implies, this feature lets you swap one specified color in the image or movie for another. Again, first set the Mode dial to either **SCN** or ⛶ . Then rotate the Control dial to select ⛀ or ⛶ . Press ⊛ so that a small frame is displayed in the bottom left of the LCD screen, and aim the camera at any color in the scene that you wish to swap out. Now press the left controller key and the color to be swapped out will appear in that left-hand frame at the bottom of the screen. Use the up/down controller keys to specify a range of colors (integers from +/–5) that will be swapped out. At the –5 setting; only the specific color is swapped; at the +5 setting, colors close the one you set are also swapped out.

Now point the camera at a color in the scene to be swapped in, and press the right controller key to select, making that color appear in the right-hand display at the bottom of the LCD. You can use the up/down controller keys to adjust

The swap feature lets you choose to substitute one color for another. In this case, anything that was dark red is now blue, while the rest of the photo is recorded in its natural color. Photo © Kevin Kopp.

the range of colors swapped in as described above. Press (DISP) to complete the setting. Colors and color ranges set in Color Swap are retained when the camera is turned off.

Saving Original Images: You can simultaneously record an original, unaltered image along with a separate Color Accent or Color Swap file. With Color Accent or Color Swap activated, press MENU and scroll to highlight [Save Original]. Select [On]. Press MENU to execute your setting. Only the transformed image will be displayed on the LCD screen in playback.

Caution: If you erase the image at this point, both the transformed and original image will be deleted.

Playback Mode

The Canon G10 provides a comprehensive range of playback and erasing options. You can review an image automatically for a selected period of time on the LCD screen immediately after recording (Rec. Review). You can also select images stored on the SD card to view at any time in Playback mode by pressing the ▶ button on the back of the camera above the LCD screen's top right corner. Select still images to review one-at-a-time in Playback mode by pressing the left (previously recorded image) or right (next recorded image) four-way controller keys, or by turning the Control dial (counterclockwise to select the previous image; clockwise to select the next image). It is not necessary to press the power button on the camera's top right shoulder to review recorded images; just press ▶ and the camera will power on in Playback mode without extending the lens.

You can see shooting information and other data about the image under review by pressing (DISP) while Single Image Playback is displayed. Press (DISP) repeatedly to cycle through four options: No Information (image only), Standard Playback Display (file number, order number of the file, date recorded, file size and type, battery icon), Detailed Display (file number, exposure and metering mode, exposure data, exposure compensation, histogram, date, battery icon, etc.), and Focus Check (which displays selectable magnified images of faces detected by Face Detection).

↺ *You are not done with your photos after recording them. You can review your successes and failures in Playback mode, learning more about your photography. You can also erase, protect, organize, process, make slide shows, and print the pictures that are stored on your memory card. Photo © Kevin Kopp.*

View recorded images in Detailed Display mode to see a wealth of shooting information.

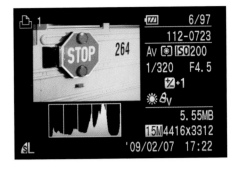

Viewing Images

Besides viewing single full-screen images one-at-a-time by pressing ▶ as described above (Single Image Playback), you can also view several simultaneously in Index Playback. Or you can magnify one image several times in Magnified Display.

Index Playback

The Zoom lever is located on top of the camera underneath the shutter button. Push this lever toward the front of the camera (counterclockwise, in the direction of the blue ▣ icon) to display up to nine of the last images recorded. Use the four-way controller keys to scroll and select from among the multiple images. As you scroll, a green frame will signify the index image that is selected. To view the selected image in Single Image Playback, pull the Zoom lever clockwise toward the blue Q icon.

Switching Sets of Index Images: You can switch to view a different set of index images on the LCD by pressing the Jump ⌂ button (same as ▣ button on the back of the camera above and to the right of the Control dial) or by pushing the Zoom lever forward during Index Playback. In either case, a Jump bar will display at the bottom of the LCD allowing you to move from one set of index prints to another by using the left/right keys or by rotating the Control dial. Hold ⊛ down and press the left/right keys to select the first or last index set, respectively. Press ⌂ again to return to scrolling through index playback.

The G10 allows you to analyze the sharpness of your photos by enlarging them to take a close look. This is especially effective for portraits and pictures that have small, precise details. Photo © Matt Paden.

Magnified Display

In Playback mode, pull the Zoom lever clockwise toward the blue Q icon to magnify the image displayed on the LCD screen. A small graphic showing the size of the magnified segment relative to the entire image will appear near the lower right corner of the screen. If you hold the lever against its spring tension, the image will digitally zoom to a maximum magnification of approximately 10x. Once the image has been magnified to any degree, you can use the four-way controller to move around the image so you can evaluate specific details (e.g. a subject's smile), particularly for sharpness and noise. If you rotate the Control dial while in Magnified Display mode, the previous or next image will be displayed at the same magnification level. You can decrease the level of magnification, and eventually cancel Magnified Display, by pushing the Zoom lever counterclockwise toward ▦ , or also cancel by pressing the MENU button.

Note: Movies and index playback images cannot be magnified.

Focus Check Display

This function is useful for checking the precise focus of recorded images. You can also change the display size and switch images, making it easy to assess facial expressions, determine if eyes are shut, and examine other details.

To set Focus Check in Playback mode, press the (DISP) button repeatedly to bring up the Focus Check screen, which is characterized by the appearance of two images; the primary photo occupies the upper left portion of the screen, and a detail from that image appears in the lower right portion. You will also see the photo's quality/resolution setting and an icon with the word SET followed by two rectangles.

A small orange frame will display on the primary image to indicate the portion that is being detailed. A white frame on the primary image indicates where the camera focused or where faces were detected during shooting. A gray frame will also be displayed where the camera may detect faces during Playback mode.

To check focus, pull the Zoom lever clockwise and the detailed image will become magnified, bounded by an orange frame with arrows. It will be large enough to closely assess details for sharpness. You can scroll with the four-way controller keys to examine different portions of the magnified image within the orange frame, or you can change the size of the image display by manipulating the Zoom lever. Press MENU to cancel.

Note: Press (FUNC/SET) while Focus Check Display is active to switch between AF or face frames within the primary image.

Jumping to Images

Using the G10's several Jump keys, represented as a vertical column of icons on the left side of the LCD, is a convenient method for quickly finding certain images. They allow you to skip over pictures you don't want to select when a large number of files have been recorded to your memory card. Make sure you are in Single Image Playback in order to select the Jump mode that best suits your need. Press 🔂 to display the Jump search mode, then use the up/down keys to select the desired Jump icon. The screen will vary slightly depending on the icon you select. You can show or hide an image by pressing ⊙ .

- 📅 **Jump Shot Date:** Select images by date they were shot, and jump to the first image recorded on that date.
- 🗂 **Jump to My Category:** Select a category (from photos recorded in either Auto Category or My Category) and jump to the first image in the category.
- 📁 **Jump to Folder:** Select a folder and jump to the first image in that folder.

With any of the icons above highlighted, use the left/right controller keys to select the date, category, or folder for playback. Then press 🔘 to confirm. The camera will switch to the selected playback mode and display a blue frame. Now you can navigate in Playback mode as usual, but the available images will be limited to those that correspond to the selected search icon. For example, if you select a date to search, only pictures taken on that date will be available for review as single images or as index photos in Playback mode until the defined search is cancelled by returning to a single image and then pressing 🔂 .

Note: If you select 🗂 when an image has not been assigned to a category, you will only be able to select 🚫 —None—as a category.

- 🎬 **Jump to Movie:** Select a movie and jump to it.
- 🔟 **Jump 10 images:** Will skip 10 images at a time.
- 💯 **Jump 100 images:** Will skip 100 images at a time.

Once highlighted, any of the above icons can also be toggled with the left/right controller keys to jump as defined. Press MENU to cancel any setting.

Note: Press 🔘 to switch the camera to the defined playback mode when 🎬 is selected.

Slide Shows

The G10 can be set to display automated slide shows using images recorded on the memory card (see page 102 for details). You can choose the way in which you want the images in the slide show to appear, as well as select the way the transition from photo to photo will look.

- ▣ : All images on the memory card will display in the slide show.
- ▦ : Choose all the images recorded on a selected date to display.
- 🗂 : Images organized into different My Category options will display in the slide show.
- ▤ : All the images from a specific folder will be shown as the slide show.
- 🎞 : Movie files only will be displayed.
- ▣ : All of the still photo files will display in the slide show.
- **1** - **3** Custom 1–3: Specific images (up to 998) from among all recorded to the memory card can be selected and saved for up to three different slide shows.

Hint: In Single Image Playback you can start a slide show immediately from the currently displayed image by simultaneously holding 🔘 and the Shortcut/Print button (🔆 🖨).

Organize your photos into My Categories, such as Events for a holiday theme, and then select that category for a fun slide show. Photo © Kevin Kopp.

My Categories

The [▶] Menu can be used to organize images into preset categories, including categories already applied to files by the [Auto Category] function (see page 82). Once the images are sorted into any of these categories, you can perform image searches (page 163), slide shows (page 102), configure digital print order (DPOF) settings (page 116), and protect or erase images (pages 105 – 106). (See page 103 for My Categories menu setting information.)

Note: This process can also be applied using index playback.

It is simple to erase images that you don't want or need, thus saving storage space on your memory card, as well as making workflow and organization easier when you download images to your computer.

Erasing Images

The Canon G10 provides several options for erasing (deleting) images from the memory card. Erased images cannot be recovered, so exercise extreme caution when performing this function. Of course, the easiest way to erase a single image is to select it in Playback mode and press the 🗑 button. On the next screen, select [Erase] or [Cancel] and press 🔘 to execute. Protected images cannot be erased with this function.

To erase more than one image at a time, select [Erase] in the ▶ Menu. You have the choice to erase just a couple of selected images, or up to 500 images, saving considerable space on the memory card. In addition, you can also delete photos between specified file numbers on the memory card, images that were recorded on a specified date, registered within a certain category, or those within a specified folder. (See page 105 for menu setting information.)

Note: Pressing ⓕ while erasure is in progress cancels the procedure. To erase all images and image data from the memory card, also format the memory card (see page 91).

Protecting Images

There are many times it is advantageous to protect important images and movies from accidental erasure. Like most digital cameras, the G10 offers the ability to specify images that can be protected. Select [Protect] in the ▶ Menu. Choose a selection method as described on page 106 and select the images that you don't want to take a chance on erasing. Selecting [Unlock] cancels this protection on the entire selection.

In-Camera Adjustments

There are many useful tools and features on the Canon G10 to facilitate various workflows and shooting styles. After the image has been recorded, you can apply changes in Playback mode with a remarkable assortment of in-camera post-processing functions. However, it is worth pointing out that many of the adjustments can be carried out more accurately with specialized software programs on a computer.

i-Contrast
The camera can be set to automatically detect and compensate for dark areas in an image, and then save the adjustments as a new image file. Select [i-Contrast] in the ▶

Menu. Then set the item's compensation at a desired level from the available choices and save it. You can then display this newly saved and adjusted image. i-Contrast cannot be performed on ▨ images. (See page 78 for additional setting information.)

Caution: When using i-Contrast, the picture quality may be reduced depending on the image, and the effect may not appear as expected. Brightness compensation may be performed an unlimited number of times on the same image, but picture quality may suffer.

Red-Eye Correction

Your G10 can automatically detect and correct for red-eye on recorded images. Select [Red-Eye Correction . . .] in the ▶ Menu. This process takes several steps, but can be worth it if you notice red-eye in an image you've just recorded (see page 108 for menu setting information). You can save corrected images either as a new file or as an overwritten file. The [New File] setting saves the corrected file with a new name (the last file number) and stores the uncorrected image. The [Overwrite] setting saves only the corrected file under the name of the uncorrected file and the original file is erased.

Note: Red-eye correction cannot be performed on ▶ or ▨ files.

Caution: Although red-eye correction can be applied multiple times to an image, the image quality will gradually deteriorate with each application. The correction frame will not automatically appear on images that have already been corrected once for red-eye, so you must use the [Add Frame] option to add additional correction.

Trimming

Trimming is a way to get rid of unwanted or unnecessary portions of a photo. It allows you the opportunity to, in effect, recompose after you have recorded the image. The ▶ Menu in the G10 offers the ability to trim images using the

The G10 offers a number of features to deal with red-eye, including a red-eye lamp and an automatic correction function in the Flash Control item of the ⬛ Menu. However, if you still see red-eye in an image during playback, you can correct it using Red-Eye Correction in the ▶ Menu.

[Trimming . . .] item. The green crop frame displayed in the LCD on an image selected for trimming can be moved and adjusted using the controller keys and the Zoom lever (see page 110 for setting details), and the orientation can be changed by pressing ⬤ . Though this feature can be handy at times, trimming deletes a portion of the image, so the resulting photo has lower resolution than the original (not necessarily a bad thing). The trimmed file is saved in addition to the original, which is still kept on the memory card.

Note: Images that cannot be trimmed are those recorded in the ⬛ Shooting mode, or with Recording Pixels settings of ⬛ , ⬛ , or ⬛ , or those resized to ⬛ (see the following page).

Resizing Images

You can use the [Resize] item in the ▶ Menu to resave high-resolution images (those shot using high Recording Pixel settings) as lower resolution images. The smaller files are much more appropriate for sharing by emailing or uploading to websites. The available resizing settings are 1600 x 1200 pixels, 640 x 480 pixels, and 320 x 240 pixels. The resized image will be saved as a new file and the original image will remain. See page 110 for detailed setting information.

Note: Files recorded in the ▣ Shooting mode, and those recorded in ▣ or ▣ formats, cannot be resized.

Adding Color Effects to Recorded JPEGs

Just as you can set the camera to record with enhanced color settings by selecting My Colors in the FUNC. Menu (see page 65), you can choose to add color effects to still image files that have already been recorded by selecting [My Colors] in the ▶ Menu (see page 110 for detailed setting information). The selections produce basically the same effects in both instances, though you may see slight variations between those recorded with My Colors and those where the effect is subsequently added. In the ▶ Menu, My Colors applies the effect and saves a duplicate file, so you keep the original image intact.

Caution: My Colors effects can be added any number of times, but image quality will diminish with each successive addition and the desired colors may not be achieved.

Attaching Sound to Images

It can be fun to record verbal comments about your pictures, adding narrative information or simply technical observations, and you can do so in Playback mode using a couple of different methods. The sound is saved in the WAVE format.

One method allows you to insert up to one minute of sound recording to any single image. Select an image in Playback mode and press the 🎤 button (the same as the

Give a little extra pop to selected colors by increasing saturation and contrast. The red in this storefront originally looked a little dull until the colors were enhanced with this handy function. Photograph © Kevin Kopp

✱ button located on the back of the camera in the upper right corner); an audio control panel will appear along the bottom of the LCD. To start the recording process, use the left/right controller keys to select ⬛ and press 🔘 , then start speaking. Both the elapsed time and the remaining time are displayed at the bottom of the screen. You can adjust the volume with the up/down controller keys. Pressing the 🔘 button pauses and resumes the recording. Press 🎤 again to stop the recording session.

A second method allows you to record only sound, without attaching the sound file to an image. This is done by using the ▶ Menu and scrolling to the item [Sound Recorder . . .]. You can record up to two hours with a choice

of sample rates, with sound quality improving successively at settings of 11.025kHz, 22.050kHz, and 44.100kHz. But the respective size of the recorded file will also increase, using more memory. You can always pause while recording, and pressing the shutter button halfway will bring you to the Shooting mode and end the recording. See page 111 for more details about how to set this function.

Rotate Images in Playback

You can choose to rotate images to various positions as you view them in Playback mode: from horizontal to vertical or vice versa. This can be helpful, particularly if you have forgotten to set the Auto Rotate function, because it allows you to take advantage of the full LCD screen for any photo, no matter what its original orientation is. Use the [Rotate . . .] selection in the ▶ Menu. (See page 112 for menu setting information.)

Movies

It is very easy to view movies recorded to the memory card on the G10's LCD screen. Press the ▶ button and use the left/right controller keys or the Control dial to select a movie—movies will be designated by the icon **SET** 🎦 that appears in the upper left corner of the LCD. Audio will have also been recorded while the video was being shot.

Watching movies in Playback mode is much like watching a DVD, only better; not only can you play, pause, and fast forward, you can even edit your movies in-camera.

Once you have selected the movie you want to view in Playback mode, press ⬢ to display the movie control panel with icons at the bottom of the screen, along with a playback progress bar. Navigate in the control panel using the left/right controller keys to highlight one of the icons and press ⬢ to activate.

- ↰ : Exit the movie review.
- ▶ : Begin viewing the movie.
- ▐▶ : View the movie in slow motion.
- ◀◀ : Skip to the first frame of the movie.
- ◀▐ : Move to the previous movie frame.
- ▐▶ : Move to the next movie frame.
- ▶▶ : Skip to the last frame of the movie.
- ✂ : Edit movies in-camera.

Highlight ▶ and press ⬢ to start the movie. Press ⬢ again at any time to toggle between pausing and resuming play of the movie. Press the up/down controller keys to adjust audio volume. While the movie is paused, scroll with the left/right controller keys or the Control dial to highlight any of the icons on the control panel that are described above. Press ⬢ to activate. To switch between showing and hiding the playback progress bar, press the ⬢ button. When playback ends and the movie stops at the last recorded frame, return to Playback mode by highlighting ↰ and pressing ⬢ . Or, to display the movie control panel at that point along the bottom of the screen, simply press ⬢ .

Viewing Movies on TV

Another option is to view movies on a TV screen. Make sure the camera is set in the Set up 🔧 Menu to the proper output—[NTSC] in U.S., Canada, Japan, among other regions; [PAL] in Europe and Asia, as well as other areas (see page 94). Connect the G10 from its A/V Out terminal (under a door on the right side of the camera) to the Video In/Audio In jacks on the TV by using the AV cable that comes with your camera. Turn on the TV first in video mode, then turn on the camera and start to play the movie.

Note: Movies cannot be played in the Index playback mode. Sound cannot be played in slow motion playback. When connected to a TV for playback, use the TV's volume controls to adjust volume.

Editing Movies

You can delete sections of recorded movies in-camera by using the left/right controller keys or the Control dial to select ✂ in the movie control panel (see above). Press 🔘 and a vertical editing panel will display on the upper-left side of the LCD screen, along with a horizontal editing progress bar along the bottom of the screen. Use the up/down controller keys to select ▣ (cut at the beginning of the movie) or ▣ (to cut from the end of the movie) from the panel. Then use the left/right controller keys to scroll along the progress bar, determining where you want to cut away portions of the movie—the blue portion of the bar indicates remaining movie; gray indicates cut pieces. Highlight ▶ and press 🔘 to review the edited movie. Select ↩ to cancel the edit and return to the movie control panel.

To save the edited portion of the movie, highlight ▣ in the editing panel and press 🔘 . Then use the controller keys to select [New File] or [Overwrite], and again press 🔘 . The [New File] option saves the edited movie under a new file name, and the pre-edit data is left unchanged in the original file. [Overwrite] saves the movie in edited form under the original file name, replacing it and deleting the pre-edit data. When insufficient space remains on the memory card only [Overwrite] can be selected.

Note: Depending on the movie's file size, saving an edited movie may take some time. If the battery runs out of power part way through the process, edited movie clips cannot be saved. Make sure the camera battery is fully charged, or use the separately sold AC Adapter Kit ACK-DC50 when extensively editing movies.

Use the G10's Playback menu to watch movies on your TV at home. ➪ *All you have to do is simply hook up the supplied AV cable between the camera and TV to show off your latest work. Photo © Jeff Wignall.*

174

Flash and Accessories

Built-in Flash Modes

The built-in flash offers advantages in a number of photographic situations. It helps you capture photos of friends and family indoors, and acts to eliminate shadows and make subjects like flowers look more natural outdoors.

Press the ⚡ button (same as right controller key) and scroll with the left/right controller keys or rotate the Control dial to highlight the icon that controls how you want the flash to operate. These options are not available when shooting movies.

⚡ᴬ **Auto:** The flash will fire only when the camera determines it is needed to ensure a proper exposure.

⚡ **On:** The flash is on and will fire every time the shutter button is pressed all the way.

⚡ **Off:** The flash is off and will not fire.

Use the menu system to gain access to additional flash options in the ⊙ Menu under [Flash Control]. The availability of additional options depends upon the active Shooting mode. These allow you to control such functions as:

- **Flash Mode:** In the Flash Control Menu, select [Auto] or [Manual] when the Shooting mode is set to either **Tv** or **Av** . This determines whether flash intensity is controlled by Flash exposure compensation or by Flash Output

↺ *The G10 gives you a number of creative controls to use with flash photography, especially when the camera is set to the Creative Zone shooting modes. Photo © Jeff Wignall.*

Sometimes a flash is used even in bright conditions, since shadows may be created due to the direction of the light. Use the flash to fill in and brighten such dark areas, as was done above to reveal the climber's face. Photo © Matt Paden.

- **Flash Exposure Compensation:** Set the intensity of the flash output on a scale from –2 EV to +2 EV in increments of 1/3 stops, when the Shooting mode is set to **P** , or when [Auto] Flash Mode has been set for Shooting modes **Tv** or **Av** . This function can also be found in the FUNC. Menu (see page 68).

Note: You cannot set Flash exposure compensation in the Movie Shooting mode.

- **Flash Output:** Found in the FUNC. Menu, the intensity of the flash can be set to one of three levels: Minimum, Medium, Maximum. This option is available for **M** Shooting mode, and for **Tv** or **Av** when the Flash Mode has been set to [Manual].

- **Shutter Synchronization:** When shooting in the Creative Zone modes, select between [1st-curtain] and [2nd-curtain] syncs. When [1st-curtain] is selected, the flash fires immediately after the first shutter curtain opens. This is the most commonly used sync mode. With the other option, the flash does not fire until just before the second curtain closes. This allows the camera to produce an image with light trails behind a subject.

- **Slow Synchro:** This enables the camera to set slower than normal shutter speeds when the flash is activated. This means that ambient background can be recorded, but also means a tripod is recommended since there is a high chance for blur due to camera shake at slow shutter speeds. This feature is always active in **M** and **Tv** Shooting modes, as well as several **SCN** modes. It is optional in **Av** , **SCN** , and **◙** .

- **Red-Eye Correction:** When activated, this option causes the camera to detect images with red-eye and corrects it before recording to the memory card

- **Red-Eye Lamp:** When turned On, a light is emitted from the camera to reduce the red reflection from the subject's retinas.

- **Safety FE:** When this function is On, the camera automatically reduces the effects of the flash illumination by changing the f/stop or shutter speed to avoid overexposing the image. Available only in **Tv** , **Av** , and **P** Shooting modes.

FE Lock

To assure that your flash exposure settings are correctly set regardless of the composition or subject placement within the image, you can lock the flash exposure (FE) setting.

Make sure the LCD display is on. Press the **⚡** button and scroll to highlight the lightning bolt in the LCD (which makes the flash fire for every shot). Aim the camera at the subject for which you want to lock the flash exposure and

press the ✳ button. The flash exposure for the built-in unit will be locked (confirmed with ✳ displayed on the LCD screen). Recompose the shot as you wish and release the shutter to record the photo. To release the FE lock, press any button other than ✳ .

Note: The FE lock cannot be used when the [Flash Mode] is set to [Manual].

Using an Externally Mounted Flash

Using an externally mounted flash on your Canon G10 affords a number of advantages. It can deliver a lot more light to the subject than the small built-in flash, allowing you to properly expose more distant subjects, and to use lower ISO settings that provide better image quality. An externally mounted Canon Speedlite flash also provides bounce capability, and, when the flash is not mounted in the hot shoe, wireless flash operation, both of which can produce more natural-looking effects in flash photography.

The camera's autoexposure function will operate with the Canon Speedlite 220EX, 430EX II, or 580EX II (except in the Manual exposure mode when [Flash Mode] is set to [Manual]). Other flash units may fire manually or not fire at all. Please check your flash manual for details.

Note: Certain functions noted in the manuals for the Canon Speedlite 220EX, 430EX II, and 580EX II cannot be performed when the flash is mounted on the G10. In addition, Since the camera's autoexposure system will trigger an externally mounted flash when shooting in ✳ or AUTO mode, settings cannot be changed. When using mounted Canon flash units other than the EX series, automatic red-eye correction is not available.

To attach an externally mounted flash unit, slide the foot on the bottom of the flash unit into the hot shoe atop the G10, and if the flash has a locking lever or control, turn it to its indicated locked position. Turn the external flash on, and turn the camera on in the ⬛ Menu. A red 🔆 will

You can bounce the light from a Canon EX series external flash unit off of a card or a low white ceiling to properly illuminate subjects, such as this fluffy black cat, without creating harsh shadows or over-exposing them. Photo © Kevin Kopp.

now appear at the top of the LCD screen to the right of the ISO speed readout. Turn the mode dial to set the desired mode as follows:

Speedlite 220EX: When this unit is mounted and [Flash Mode] is set to [Auto], the flash unit will automatically adjust its output, and you can adjust Flash exposure compensation (even if the flash itself is set to E-TTL). To directly adjust the flash output, switch [Flash Mode] to [Manual], or switch to Manual (M) Shooting mode. Refer to the guide number listed in the flash's user guide for the optimum aperture values and ISO speeds at various distances.

Canon's top-of-the-line Speedlite can be mounted on the Power-Shot G10 to give your system added flexibility.

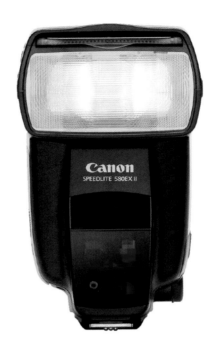

Speedlite 430EX II and 580EX II: When either of these is mounted and [Flash Mode] is set to [Auto], the flash will automatically adjust its output, and you can adjust Flash exposure compensation. You can also adjust Flash exposure compensation on the flash unit.

Taking Photos with an External Flash Unit

To take a picture with an externally mounted flash with the camera and flash turned on and the mode selected, press the shutter button half way—the flash is charged when its pilot lamp (a ready-light) is lit. Now press the shutter button in all the way to shoot the image.

To set an externally mounted flash, turn the camera on in Shooting mode, turn the flash on, and hold the ⚡ button down for one second or longer to display the [External Flash Settings] screen. Use the up/down controller keys or the Control dial to select the function you wish to set, and press the MENU button twice to return to Shooting mode.

Note: You can also select [Flash Control] in the 📷 Menu and press 🔘 to display the [External Flash Settings] item.

The type of flash you use will affect the available settings on your camera. To see more about the settings, refer to the charts below or to the manual for the flash or Speedlite Transmitter that you are using.

Speedlite 220EX Settings

Item	Options	Shooting Mode			
		P	Tv	Av	M
Flash mode	Auto	yes*	yes*	yes*	no
	Manual	yes*	yes*	yes*	yes
Flash Exp. Comp [1]	-3 to +3	yes*	yes*	yes*	no
Flash Output [2]	1/64 to1/1 (in 1/3 steps)	yes*	yes*	yes*	yes*
Shutter Sync.	1st Curtain	yes*	yes*	yes*	yes*
	2nd Curtain	yes*	yes*	yes*	yes*
Slow Synchro	On	yes*	yes	yes*	yes
	Off	yes*	no	yes*	no
Red-Eye Corr.	On	yes*	yes*	yes*	yes*
	Off	yes*	yes*	yes*	yes*
Red-Eye Lamp	On	yes*	yes*	yes*	yes*
	Off	yes*	yes*	yes*	yes*
Safety FE [1]	On	yes*	yes*	yes*	no
	Off	yes*	yes*	yes*	yes

1 *Can be set when [Flash Mode] > [Auto]*
2 *Can be set when [Flash Mode]>[Manual]*
* *Settings retained after camera is turned off .*

183

Speedlite 430EX II/580EX II Settings

Item	Options	Shooting Mode P	Tv	Av	M
Flash Mode [1]	Auto	yes*	yes*	yes*	no
	Manual	yes*	yes*	yes*	yes
Flash Exp. Comp [1,2]	-3 to +3	yes*	yes*	yes*	no
Flash Output [1,3]	1/128 4 to 1/1 in 1/3 steps	yes*	yes*	yes*	yes*
Shutter Sync. [1]	1st Curtain	yes*	yes*	yes*	yes*
	2nd Curtain	yes*	yes*	yes*	yes*
	Hi-speed	yes*	yes*	yes*	yes*
Slow Synchro	On	yes*	yes	yes*	yes
	Off	yes*	no	yes*	no
Wireless Func. [1,5]	On	yes*	yes*	yes*	yes*
	Off	yes*	yes*	yes*	yes*
Red-Eye Corr.	On	yes*	yes*	yes*	yes*
	Off	yes*	yes*	yes*	yes*
Red-Eye Lamp	On	yes*	yes*	yes*	yes*
	Off	yes*	yes*	yes*	yes*
Safety FE [2]	On	yes*	yes*	yes*	no
	Off	yes*	yes*	yes*	yes
Clear Flash Settings [6]	Resets to default settings	yes	yes	yes	yes

1 Settings from the flash applied when camera is turned on
2 Set when [Flash Mode]>[Auto]
3 Set when [Flash Mode]>[Manual]
4 If using Speedlite 430EX II, 1/64 will be set
5 [On] and [Off] are set with camera, other settings are set with flash (Cannot use with Speedlite 430EXII)
6 [Reset All], under the camera's tool menu, can reset [Slow Synchro], [Safety FE], [Red-Eye Corr.], and [Red-Eye Lamp] to their default settings.

* Settings are retained after the camera is turned off.

There are several points to keep in mind when shooting with a flash:

- Flash photography cannot be used with Focus Bracketing mode and the AEB mode. Even if the flash fires, only one image will be recorded
- The built-in flash settings will not work with an external flash mounted.
- Set the Flash exposure compensation on the flash to 0 on when adjusting Flash exposure compensation using the camera.
- The flash's set up menu cannot be accessed while the external flash is set to stroboscopic flash (only if using the 580EX II).
- When [Wireless Func.] is [On], [Shutter Sync]>[2nd-curtain] cannot be set.
- The flash can be set to quick flash mode for continuous shooting (pilot lamp will be green). In this circumstance, light emission may be smaller than when using full flash (pilot lamp will be red).
- Flashes (especially if they are high voltage) and flash accessories made by other manufacturers may cause camera malfunctions.

Using the TC-DC58D Teleconverter

The best conversion lens available for the G10 is the Canon teleconverter TC-DC58D, a high-quality multicoated supplementary lens that increases the effective focal lengths of the camera's built-in zoom lens by a factor of 1.4x: Theoretically the 28-140mm effective focal length lens built into the camera becomes a 39-196mm zoom when the teleconverter is mounted. However the teleconverter is not designed to be used at wide-angle and normal zoom settings, and will capture and display a vignetted or incomplete circular image when used in that manner. To use the teleconverter as intended, make sure to set the camera's zoom lever to a telephoto focal length, preferably one close to the maximum end of the zoom range, and check the corners of the image on the LCD before you shoot to make sure you are getting full-area coverage. The effective aperture range remains the

This picture and the one on the opposite page were taken from the same position. Above is without the TC-DC58D teleconverter mounted. Then the teleconverter was placed on the lens without pressing the Zoom lever to shoot the photo to the right. Photo © Frank Gallaugher.

same, though the light transmission does decrease by an insignificant amount because of the added optical elements.

Mounting the TC-DC58D teleconverter on the G10 first requires the Conversion Lens Adapter LA-DC58K, essentially an extension tube that bayonets onto the front of the G10 between the teleconverter and the camera lens to position the teleconverter at the proper distance. To mount the Conversion Lens Adapter, you must first remove the textured bayonet ring cover surrounding the camera lens by holding in the ring release button (located at about 5 o'clock on the lens-surround when the lens is pointing toward you). Turn the ring counterclockwise about 1/8 turn and lift it off. This exposes the 3-lug bayonet used for mounting the rear part of the Conversion Lens Adapter on the camera.

The TC-DC58D teleconverter significantly magnifies distant subjects when the G10's focal length is set to its longest telephoto setting. Photo © Frank Gallaugher.

Position the white orientation dot on the rear of the tube opposite the orientation dot on the camera (small, black, indented, and difficult to see) located at about 3 o'clock. Push the adapter over the bayonet mount, and turn it clockwise until it clicks in place. The orientation dot on the adapter should now be at about 5 o'clock, just opposite the ring-release button when properly mounted on the G10. Now remove any caps that came with the converter or adapter and screw the teleconverter's rear (58mm male) thread into the (58mm female) front of the adapter making sure to screw it in all the way to secure it. If the installation is correct, you will see a frame-filling (non-vignetted) image on the LCD screen when you turn the camera on in shooting mode and zoom to a long telephoto setting.

Tip: Screw the teleconverter into the conversion lens adapter beforehand, and carry both as a single unit in the furnished drawstring pouch. That way you can mount it on the camera more conveniently when you want to use it. To prevent losing the bayonet ring cover, keep it in the same drawstring pouch when you remove it.

Note: If the built-in flash is used with the teleconverter attached, the outer edges of the images (particularly the lower right) may be darkened. If the corners are cut off on the LCD image when shooting with the teleconverter at too wide a setting of the zoom lens, that is how they will appear in the captured image. If you use the optical viewfinder when shooting with the teleconverter, a portion of the view may be blocked. If this poses a problem, use the LCD screen to compose the picture. It is not possible to attach a lens hood or filter to the teleconverter.

Converter Settings Using Image Stabilization (IS)

When shooting in (IS) mode using the teleconverter, it is necessary to input information telling the camera that the converter is in use. This allows the image stabilization feature to provide optimum compensation to minimize the effects of camera shake at longer effective focal lengths.

To set the IS system to operate properly with the teleconverter, select [Converter] in the 📷 Menu. Scroll to select [TC-DC58D], and confirm by pressing MENU. The camera-shake icons on the LCD screen will change according to the selected [IS Mode]: 🖐 for [Continuous], 📷 for [Shoot Only], and ➡ for [Panning].

Note: When you remove the telephoto converter from the camera, you must remember to return the above-mentioned converter setting to [Off] so that the image stabilization (IS) system will operate correctly.

Camera shake is more evident at longer focal lengths, so it is helpful ➪
to properly set the image stabilization options in the ICON20 Menu
when using the TC-DC58D teleconverter and handholding the G10.
Photo © Jeff Wignall.

Index

AE Lock 48, **141**
AEB (Autoexposure Bracketing)
Mode **66, 141**
AF-Point Zoom **74**, 128
AF Frame 15, 39, 41, 74**,** 76, 79,
123–125, 126, 128–130, 134,
138–140
AF Mode **76**
AF-Assist Beam **80**
Aperture Mode **50, 145–146**
Audio **87**
Autofocusing 17, 29**, 122–131**
Auto Category 42, **82**, 105, 106,
163, 165
Auto ISO Shift **47–48, 79**, 143
AUTO Mode **27, 49**, 73
Auto Rotate 41, **94**

Battery 14, 23, **24**, 38, 41, 42,
84, 89
Built-In Flash Modes **177–180**

Camera Shake Warning 18, 39,
44, 46, **47**, 79, 179, 188
Center-Weighted Metering **139**
Clear All Selections **116**
Clock Display **91**
Color Temperature 63, 70, 149,
150, 151
Compression 42, 55, 57, **59, 69,**
71
Continuous Shooting Modes 39,
122, 148
Control Dial 15, 17, **53**
Converter **83**
Create Folder 41, **92**
Creative Zone 48, 62, 143, 145,
177, 179

Custom Display 43, **83**
Custom Settings **50,** 85, 86, 95
Custom White Balance **64–65,**
152

Date/Time **26,** 31, **91**, 105, 106,
115, 116
Digital Zoom 41, 52, 65, **76**, 124,
128, 129, 134
Distance Units **94**
Downloading 25, 31, **33–34,** 56,
112, 166
Drive Modes 41, **121–122**
Drive Settings **78**

Erase 26, **30**, 39, 91, **105,** 157**,**
166–167, 168
Evaluative Metering 124, **138**
Exposure 49–50, 66, 79, **137–147**
Exposure Compensation 15, 38,
39, 40, 41, **140–141**, 147, 152
Externally Mounted Flash 68, 76,
147, **180–185**

Face Detect Feature 14, 17, 43,
74, 82, 122, 124, **126–128**, 159
FE Lock 39, 41, 141, **179–180**
File Formats **55**
File Numbering 42, 43, **92,** 105,
115, 116, 167, 168
Flash Photography **177–185**
Flash Control 68, **76–77,** 169,
177, 183
Flash Exposure Compensation **68,**
177, **178**
Flash Range **47**
Focus Bracketing **67, 130**

Focus Check Display 43, **81**, 159, **162**
Format (memory card) 26, **91**
FUNC. Menu 41, 54, 59, **61–71**, 81

Hard-to-Focus Subjects **129**
Histogram 28, 41, 42, 43, 80, 84

i-Contrast 17, 41, 42, **78**, 85, 98, **108**, **152**, **167–168**
Image Quality 18, **46**, 56, 170
Image Stabilization (IS) 18, 29, 41, 44, **47**, **83**, 148, **188**
In-Camera Adjustments 65, **152–157**, **167–167**
Index Playback 102, 104, **160, 163, 165, 174**
Information Display **43**
ISO 14, 15, 38, 39, 45–46, 47–48, 137, 152

JPEG **55**, 56, 57–59, 65, 69, 70–71, 81, 152, 154, 155
Jumping to Images 39, 160, **163–164**

Language **27, 94**
LCD Brightness 88, **89**
LCD Screen **15**, 37, 39, **41–43**
LED Indicators **44**

Macro Mode **131**
Magnified Display **161**
Manual Controls **17**
Manual Focus Mode (MF) 17, 39, 40, 45, 67, 80, 122, 125, 130, **132–134**
Manual Focus Plus AF **134**
Manual (Exposure) Mode **50, 146–147**

Memory Card 23, 25–26, 31, 32, 52, 55, 56, 69, **91**, 102, 105, 106, 163, 164, 167, 172, 174
Menus 54, 61, 73, 101
Metering **138**
MF-Point Zoom **80**, 133, 134
Mode Dial 38, 40, **48–52**
Movies **32, 52**, 71, 87, 161, **172–174**
Moving the AF Frame **125**
Multiplier Factor 76, 85
Mute 27, **87**
My Camera Menu 95, **96–97, 118–119**
My Category **103–105**, 106, 115, 116, 163, **165**
My Colors 42, **65–66, 110**, 151, **154**
My Menu **97–98**

ND Filter (Neutral Density) **68, 153**
Neck Strap **23**
Night View **44**

Panoramic Images 48–49, **51–52**
Play Menu **101–112**
Playback Mode 43, 55, 101, **159–174**
Power Saving **89**, 90
Print 30, **94**, **113–116**
Program AE Mode **49**, 142
Program Shift 143, **144**
Protecting Images **106–107, 167**

Quality **57**

RAW **56**, 71
RAW + JPEG 58, **81**
Rec. Menu **74**
Recording Pixels 7, **57, 70**
Red-Eye Correction 41, 42, 78, 89, **108, 168**, 179, 183

Reset All **95**
Resize 42, **110, 170**
Resolution (image) 7, **57, 70,** 110, 162, 170
Resume 30, **112**
Review Info **80**
Rotate **112, 172**

Safety Shift **79**, 144
Save Settings **85**
Scene (SCN) Modes 50, **148**
Screen Brightness **43**
Self-Timer 39, **78**, 97
Select All Images **116**
Select by Category **116**
Select by Date **115**
Select by Folder **116**
Select Images & Qty **114**
Select Range **115**
Servo AF **75, 126**
Set Up Menu **86, 118**
Sharpness **29**, 65, 67, 71, 161
Shooting Mode 27, 41, **48**, 50, 61, 73
Shooting Mode Menus **73–98**
Shortcut Button 39, 47, 79, **84**, 130
Shutter Speed 17, 41, **46**
Shutter Speed Mode **50**, 144
Single Shot **121**
Slide Show **102, 164**
Sound 27, 42, 52, **87–88**, 97, **111,** 119**, 171**
Sound Recorder 111
Speedlite 220EX **180–181, 183**
Speedlite 430EX II 180, **182, 184**
Speedlite 580EX II 180, **182, 184**
Spot AE Point metering 41, **79,** 125**, 139–140**
Stitch Assist 48, **51**

Teleconverter 14, 47, 83, **185–188**
Time Zone 41, **90**
Transfer Order **112**

Transition 102, **112,** 164
Trimming 42, **110,** 168
Tripod 39, 44, 47, 148, 153, 179

Video 52, **94, 172**
Viewfinder (optical) **37**, 38–39, 84, 188
Viewing Images **160**
 See also Playback Mode
Volume 32, **87,** 112, 171, 173–174

White Balance (WB) **63–64**, **149–152**

Zoom Lever 38, 40
Zooming to Check Focus **128**